POSTCARD HISTORY SERIES

Lake Bluff

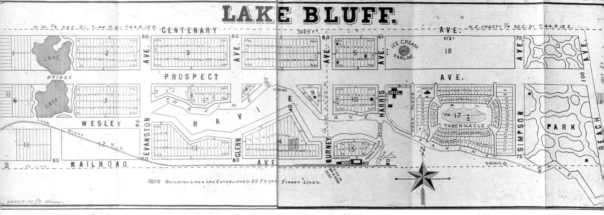

This trifold map was included in the "1877 Lake Bluff Camp Meeting Annual." It shows the street plat for the Lake Bluff Camp Meeting grounds as well as the cottage lots for sale. Centenary Avenue was later named Center Avenue, and Railroad Avenue was to be known as East Sheridan Place. The map clearly shows the railroad's spur line, which went east down Railroad Avenue to a turnaround at the end of the street. This map was found in 1926 in a window frame of the old Sheridan Inn after a fire had destroyed most of the abandoned building.

On the front cover: This postcard shows Lake Bluff scenes from around 1910. (Courtesy Vliet Museum of Lake Bluff History postcard collection.)

On the back cover: This *c.* 1910 postcard shows the Lake Bluff Village Hall, built in 1905. (Courtesy Vliet Museum of Lake Bluff History postcard collection.)

POSTCARD HISTORY SERIES

Lake Bluff

Lyndon Jensen and Kathleen O'Hara

ARCADIA
PUBLISHING

Published by Arcadia Publishing
Charleston SC, Chicago IL, Portsmouth NH, San Francisco CA

Printed in the United States of America

Library of Congress Catalog Card Number: 2007940661

For all general information contact Arcadia Publishing at:
Telephone 843-853-2070
Fax 843-853-0044
E-mail sales@arcadiapublishing.com
For customer service and orders:
Toll-Free 1-888-313-2665

Visit us on the Internet at www.arcadiapublishing.com

*This book is dedicated to Tom Tincher, who has served as president
of the Vliet Museum of Lake Bluff History from 1996 to 2008,
and whose leadership and vision have been responsible
for significant growth of the museum.*

CONTENTS

ACKNOWLEDGMENTS

The authors would like to thank the Vliet Museum of Lake Bluff History, which has been in existence for the past 25 years and holds the collection of postcards and photographs found in this book. The mission of the Vliet Museum is to preserve and promote the unique history of Lake Bluff through its collection of artifacts and memorabilia. The museum is named in honor of Elmer Vliet, Lake Bluff's longtime historian who donated the initial collection.

A very special thank-you goes to Janet and Herb Nelson, who patiently and tirelessly edited this book. We would also like to thank Philip Ross, Lynne Grenier, Pam Russell, and the entire Vliet Museum Board of Directors for their help. Our appreciation to the dedicated museum docents and volunteers, the Village of Lake Bluff, the staff at Lake Bluff Public Library, and to the entire community of Lake Bluff for their support of the museum and its mission.

INTRODUCTION

Long before the settlers arrived, the Potawatomi Indians appreciated the beauty of Lake Michigan and its ravines. Although their villages were established farther south and west of what is now Lake Bluff, the deep ravines near the lake were used for hunting and council meetings. Young saplings were bent into "trail trees" to become guideposts for the footpaths.

According to local lore, the French explorers Jacques Marquette and Louis Jolliet landed on the beach here in 1673 and met with the Potawatomi chiefs. This scene is depicted in a mural in Lake Bluff's East Elementary School painted in 1926 by local artist Marguerite Kruetzberg. Evidence that French Jesuit missionaries came through the area was uncovered in the 1890s when a tree near Green Bay Road was cut down and split, uncovering a cross carved in the truck. In the early 1700s, the cross symbol was often used as a trail marker.

The United States government opened the land for settlers in 1836. The first to arrive were John and Catherine Cloes, originally from Germany; they purchased 100 acres running from the lake to the Green Bay trail. John Cloes was a blacksmith, locksmith, and gunsmith who set up his shop along the east side of the Green Bay trail. He and Catherine and their seven children also farmed about 10 acres of the land.

Mary and William Dwyer, originally from Ireland, arrived with their family the following year, 1837, and opened a stagecoach stop and tavern on the west side of the trail just north of Rockland Road. It soon became both the social and political center for the Irish immigrants who had come to work on the Illinois and Michigan Canal. Attracted by the cheap land prices of $1.25 per acre, many soon made this area their home.

Dr. Richard Murphy, the brother of Mary Dwyer, was elected as state representative for this area in 1839. He served for six years in the state legislature until Lake County separated from McHenry County. Known for both his charm and Irish wit, he soon became friends with other young legislators, including Abraham Lincoln and James Shields. It was in 1852 that James Shields, the only man to serve as a U.S. senator from three different states, spoke to local residents at the Dwyer Tavern. The occasion was his opportunity to thank them for naming their township after him.

By the time of the Civil War, there were about 100 people residing in this area, which they called Rockland, named by some former residents from Rockland County, New York. John Cloes, the first settler, was lured to California by the gold rush in 1850 and died in Sacramento shortly after arriving there. Catherine Cloes, left to care for the family with the youngest child just two years old, joined with another early settler, Henry Ostrander, to operate the Cloes brickyard on her property. It became a successful local business lasting until the dawn of the 20th century.

The first school was established in 1869, a one-room white wood building that could house up to 90 students and one teacher. It was built on the northeast corner of Green Bay and Rockland Roads and would serve as Lake Bluff's only school until 1895, when a new four-room brick school was built on the east side of town.

In 1875, during the great industrial expansion following the Civil War, a group of Methodist businessmen and ministers led by Chicago financier Solomon Thatcher decided to capitalize on the newly acquired leisure time of a growing American middle class. They formed the Lake Bluff Camp Meeting Association and purchased 200 acres along Lake Michigan, 160 acres from Judge Henry Blodgett and 40 acres from the Cloes family. Believing the name Rockland was not picturesque enough, these astute businessmen changed the name to Lake Bluff to attract the prosperous midwesterners they sought as customers. Lake Bluff became the official name of the post office in 1882.

The Lake Bluff Camp Meeting was greatly influenced by the chautauqua movement that began in Upstate New York at Lake Chautauqua. The concept was to provide cultural, social, religious, educational, and recreational experiences for families in a beautiful natural environment. This new summer resort, enhanced by direct train transportation from Chicago, was modeled after Oak Bluffs on Martha's Vineyard.

Lake Bluff, during the time of the Lake Bluff Camp Meeting, boasted over 30 hotels and boardinghouses. Cottages were also offered for sale, to be built on 25-foot lots within 20 days for $250, and completely outfitted camping tents were rented to those who enjoyed the outdoors. The Lake Bluff Camp Meeting was an almost instant success.

Thousands flocked here during the summer months to enjoy the lake's cool breezes, the wide sandy beaches, and the leafy shade of the ravines while participating in the many lectures, assemblies, and events offered by the Lake Bluff Camp Meeting Association. Classes were held in such things as foreign language, music, photography, and elocution. Kindergarten was offered for the young children, allowing the adults to enjoy the varied activities offered by the chautauqua summer programs.

Lake Bluff's Hotel Irving, five stories high, could accommodate 500 guests and offered running water in the rooms. When it was built in 1883, it was the largest hotel between Chicago and Milwaukee. Boasting shops, arcades, tennis courts, a bowling alley, and a ballroom, the hotel was a popular destination for many prominent dignitaries of the day, including Clara Barton, founder of the American Red Cross, and Lucy Hayes, wife of the president of the United States Rutherford B. Hayes.

Directly across Prospect Avenue from the Hotel Irving was the tabernacle, an assembly hall that was known to seat 2,500 people. Built of wood with large wooden doors that could be opened in the event of overflow crowds or to catch a summer breeze, the tabernacle hosted the numerous events and chautauqua programs sponsored by the Lake Bluff Camp Meeting Association. A frequent speaker was Frances Willard, founder of the Women's Christian Temperance Union, who was instrumental in making Lake Bluff the center of the temperance movement in the 19th century. It was here in the summer of 1881 that various temperance groups met and agreed to form the national Prohibition Party that would result in the passage of the 18th Amendment to the United States Constitution.

James Hobbs, president of the Lake Bluff Camp Meeting, and his wife Marilla were the original benefactors of the Methodist Deaconess Orphanage, which was later known as the Lake Bluff Children's Home. The Hobbses donated the first building, named in honor of Marilla when it was dedicated in 1895. Beginning with the six young children taken from the streets of Chicago, the Lake Bluff Children's Home grew into a highly regarded institution that often served over 200 children at a time. The original all-wood structures were replaced in the 1920s and 1930s with handsome Georgian-style brick buildings that housed dormitories, a hospital, a bakery, and a dining hall. This complex occupied an entire block on East Scranton Avenue between Evanston Avenue and Glen Avenue. The Lake Bluff Children's Home thrived until the advent of the foster care system in the late 1960s, at which time the Lake Bluff Children's Home was disbanded. The buildings were torn down in 1979 for want of a buyer.

By the end of the 19th century, the popularity of the Lake Bluff Camp Meeting had greatly diminished. Economic hardships in the country and the destruction of the Hotel Irving by fire in 1897 led to reduced interest in the summer camp meeting. Lake Bluff was incorporated as a

village in 1895 and assumed many of the duties formerly performed by the association. Instead of playing host to the thousands of summer visitors who had thronged the beaches and summer cottages, Lake Bluff began to settle into small-town village life.

The period just before World War I brought significant change to Lake Bluff. Several substantial year-round homes were constructed, along with a scattering of mansions set on large extensively landscaped grounds. In addition to the influx of permanent homeowners, a group of artists, writers, and those with a more bohemian bent took up residency in a small area near the lake. Known as the "artists colony," its residents included Alice Corbin Henderson, coeditor of *Poetry* magazine, Lucius Cary, a writer for the *Saturday Evening Post*, and writer and editor Sherwin Cody (a cousin of "Buffalo Bill" Cody). Joyce Kilmer also visited, and it is said the village's heavily wooded bluffs and ravines were his inspiration for his poem "Trees." Margaret Anderson, editor of the *Little Review*, rented a cottage and scandalized the town by smoking cigarettes and wearing trousers. It was Margaret Anderson who achieved fame by bringing James Joyce's book *Ulysses* to America. She also proceeded to bring controversy to Lake Bluff by inviting the anarchist Emma Goldman to visit, as well as poets Carl Sandburg and Vachel Lindsey.

By the time the United States entered World War I in 1917, the population of the village was about 700 residents. Lake Bluff enthusiastically supported the war effort. Seventy men served in the armed forces, and money was raised to send an ambulance to France along with a local man as its driver. The *Chicago Tribune* declared Lake Bluff the "most patriotic town in America" because it raised more money and sent more men to the war than any other town of its size. The war memorial was built on the village green in 1919 with the funds left over from the ambulance drive.

The 1920s brought renewed growth and interest in expanding the village into a full-fledged suburb. A comprehensive plan was developed, and the uptown area was revitalized. Plans were made to develop the land west of Green Bay Road. Housing developments were laid out, and a shopping area similar to Market Square in Lake Forest was to be built surrounded by large apartment buildings and homes on narrow lots. However, all building plans ended in 1929 when the stock market crashed and the Great Depression followed.

The 1950s and 1960s brought the postwar growth and the baby boom generation. Lake Bluff came into full swing as a North Shore suburb. New ranch homes nestled next to quaint summer cottages, and the land west of Sheridan Road began to be developed for the young families of veterans. As the housing developments grew, the population increased, especially the number of school-age children, and it became necessary to build three new schools, two elementary and one junior high.

In 1951, Gen. Douglas MacArthur brought excitement to Lake Bluff when his motorcade, headed north through the village on Sheridan Road, was diverted without his knowledge. The procession was halted, and the general was asked to place a wreath in front of the war memorial. Lake Bluff's residents lined the streets along with the schoolchildren, who had all been dismissed from classes to see firsthand the famous general who had just been dismissed from his Korean command by Pres. Harry S. Truman.

Lake Bluff, in the 21st century, has evolved into a family-oriented blend of suburban comfort and small-town charm. Its eclectic architecture, remnants of summer cottages mixed with typical North Shore housing, and a thriving town center with small boutique shops set in a national historic district, help define the village today.

Excellent municipal government, fine schools, and an outstanding park system provide the amenities expected by today's residents. The beaches, bluff, and ravines characterize what Lake Bluff was in its summer resort days and still represent today's beautiful town on the shores of Lake Michigan.

One

In the Good Old Summertime

Lake Bluff thrived as a summer resort for almost a quarter of a century from 1875 to 1899, hosting thousands of summer visitors. Hotels, boardinghouses, and cottages were swiftly built to accommodate these summer guests who arrived to participate in the wide variety of events offered by the Lake Bluff Camp Meeting Association and to enjoy the natural beauty of the beaches and ravines.

The association built piers and bathhouses along the beach for the guests' benefit. It also provided footpaths and rustic bridges over the ravines. The railroad provided ready transportation and made Lake Bluff an attractive destination for midwestern families whose breadwinners could easily make the trek from Chicago. The cultural experiences offered by established chautauqua programs, along with enhanced recreational facilities, encouraged members of the just-emerging middle class to use their newly acquired vacation time in Lake Bluff.

A 10-acre lake with its own small island was created when a concrete dam was built around the newly drilled artesian well. Known as Artesian Lake, it was a popular spot for picnicking and boating. It covered the area from what is now East Sheridan Place north to uptown. It was drained in 1904 to make way for the railroad underpass.

Although the Prohibitionists appeared to dominate the Lake Bluff Camp Meeting, a large group of young people came with their families every summer for fun and summer adventure. Known as the "Kelly Klub," these young people and their friends played tennis, bowled, and held evening parties in their homes and on the beach. They often spoofed the more serious temperance people by posing on the tennis courts with large cutouts of liquor bottles.

By the end of the 19th century, the Lake Bluff Camp Meeting was waning in popularity. However, the lure of the wide sandy beaches and cool shady ravines continued to attract summer visitors into the early 20th century, although the numbers were greatly diminished. As the community became home to more year-round residents, many of the old hotels, long abandoned and derelict, were torn down or destroyed by fire.

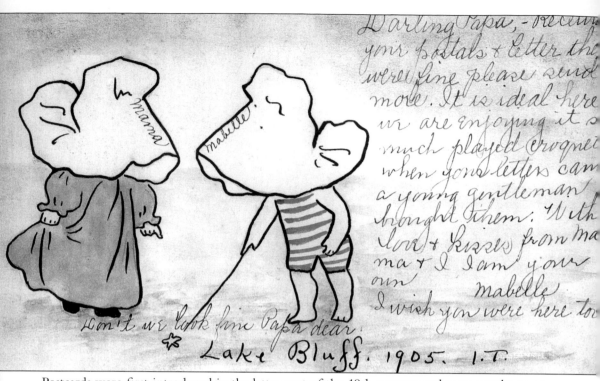

Postcards were first introduced in the latter part of the 19th century and soon caught on as a simple yet personal way of communication. This delightful hand-drawn and hand-colored postcard is from 1905. Maybelle and her mama are unknown, but this long-kept and treasured card shows the popularity of Lake Bluff as a summer resort and the attractions of its beaches and ravines. It was an oasis in the Midwest for people to escape the hot, sticky days in the city or the dry winds of the farmland of the Central Plains.

The Potawatomi Indians, whose villages were farther south and west, used the area as their council grounds. The ravines acted as natural amphitheaters. The Potawatomis used trail trees as guideposts to point the way to the council grounds. Young tree saplings were bent and then tied so that the tree would grow as a living signpost. There were two known trail trees in the village, and both were still in existence in the 20th century. One was located in the 400 block of Scranton Avenue and came down in the 1940s. The other trail tree was on North Avenue, and disease destroyed it in the 1960s.

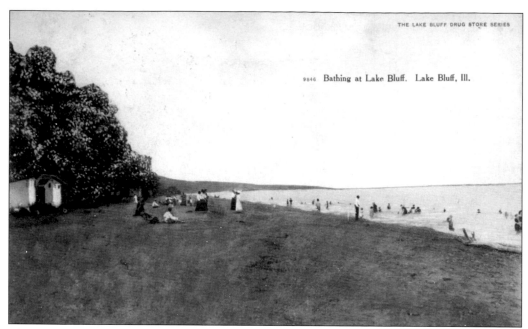

9846 Bathing at Lake Bluff. Lake Bluff, Ill.

The wide sandy beaches were a main attraction to Lake Bluff. A local ordinance forbade people from wearing their bathing suits anywhere except on the beachfront; therefore, numerous public and private bathhouses were built to allow for changing clothes.

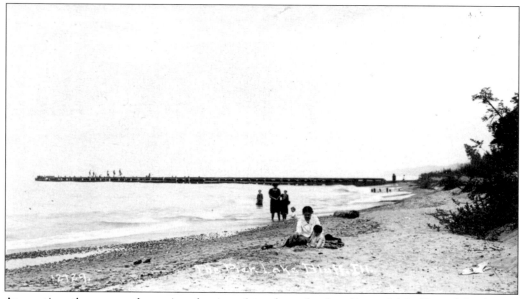

At one time there were three piers that jutted out from the shoreline, which allowed for diving, fishing, and the mooring of boats. They were made of wood, and the largest of them extended several hundred feet into the lake.

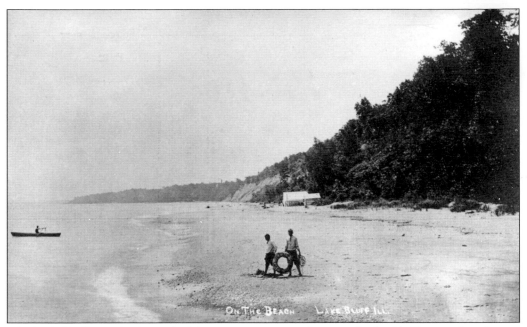

The high bluffs overlooking the lake are a prominent feature of Lake Bluff. Here they form a striking backdrop for the two young lifeguards on the beach.

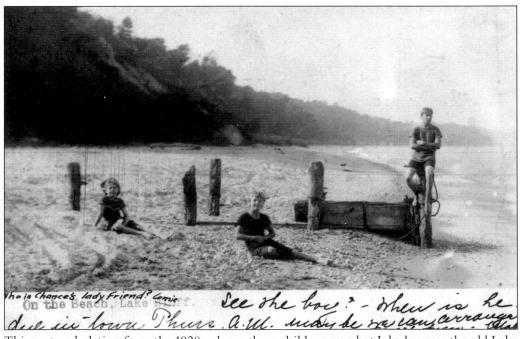

This postcard, dating from the 1920s, shows three children on a hot July day near the old Lake Bluff Camp Meeting pier. Lake Bluff in the 1920s was a growing village. The first municipal plan was adopted, and it included the development of new housing subdivisions west of the downtown. The great stock market crash of 1929 thwarted these ambitious designs.

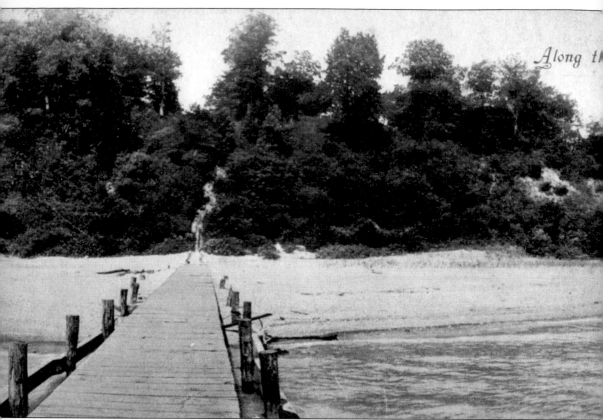

This rare double-fold postcard shows a panoramic view of the beach looking northward from the old wooden pier. This impressive view gave rise to the desire of camp meeting founder Solomon Thatcher to create a resort where people might rest from the "tumult and excitement of city life." At the end of the first summer assembly in 1876, the *Chicago Tribune* reported seeing

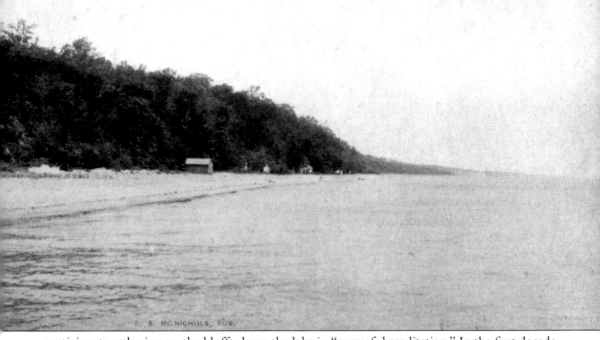

each, Lake Bluff, Ill.

E. S. McNICHOLS, PUB.

participants gathering on the bluffs above the lake in "prayerful meditation." In the first decade of the 20th century, wealthy Chicagoans discovered the breathtaking views from the bluffs and built their great houses overlooking the lake. The area became known to Lake Bluff's locals as "Mansion Row."

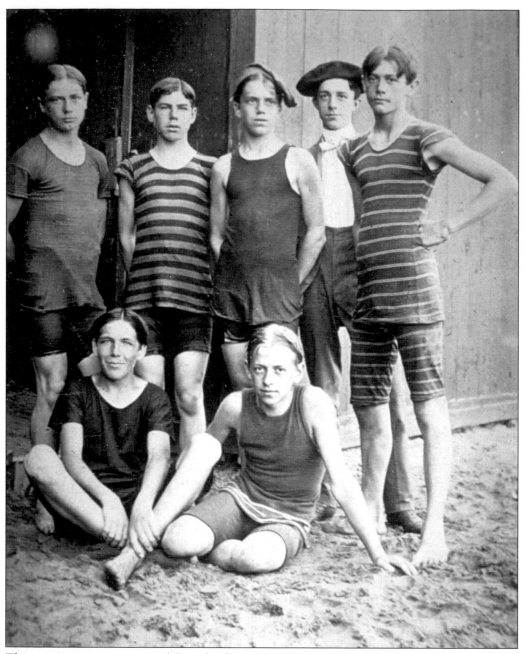

These seven young men, modeling the finest in 1890s swimwear, were members of the Kelly Klub, a group of young summer residents. In the last decade of the 19th century, the club played a prominent role in the social life of Lake Bluff's summer society. Here they are shown in front of one of the numerous bathhouses that lined the shoreline.

This path along the lakefront was a popular spot for the Lake Bluff Camp Meeting participants and later for the summer visitors who came to the Lake Bluff resort. It circled the lakefront park on the high bluffs. A gazebo bandstand stood here and was used to host summer concerts as part of the chautauqua experience.

The rustic path shown in this card was located at what is now the end of East Scranton Avenue and provided direct access from the bluff to the beach. This 19th-century path is still in existence and used today. Also shown is one of the beach houses.

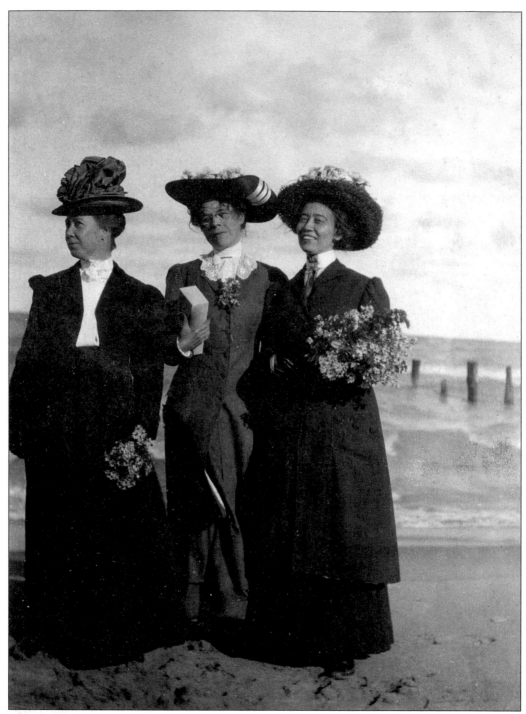

Three charming young women pose on the beach, celebrating Mother's Day 1912. In the background can be seen remnants of the old wooden pier from the camp meeting days. At this time, just preceding the start of World War I, the trend toward building year-round homes had begun, and with the population exceeding 700, Lake Bluff was evolving from summer resort into a North Shore suburb.

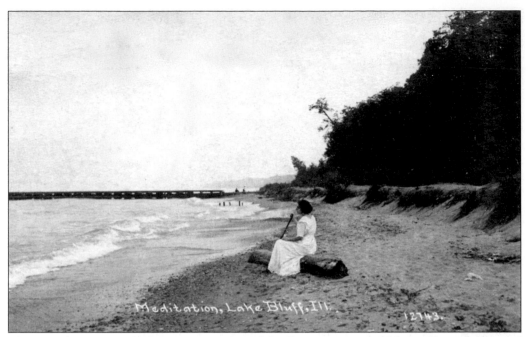

This appealing postcard of a young woman with her lute, sitting on a driftwood log, emphasized the peaceful beauty of Lake Bluff as well as its attraction as an art and literary colony.

This card shows several young girls taking advantage the temperate, restful, and serene retreats for visitors to enjoy. Drawn to the heavily wooded ravines were not only those interested in nature but also those who understood that it was several degrees cooler than the rest of the topography. This was of particular note to women visitors who were encumbered by the multiple layers of clothing dictated by fashion and modesty.

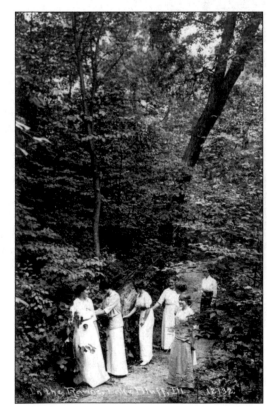

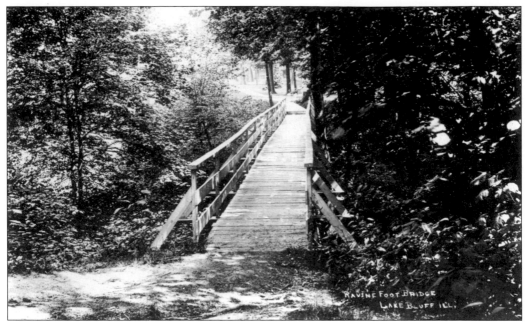

Both of these postcards show different views of the same wooden bridge built by the Lake Bluff Camp Meeting Association. This bridge, built over a ravine, connected Sylvan Road to Glen Avenue. Several of these rustic footbridges were built for the summer visitors to enjoy the lush beauty of the heavily forested ravines. On the cover of the 1877 Lake Bluff Camp Meeting Association's annual was printed, "Come forth into the light of things; let nature be your teacher," a quotation from William Wordsworth. This quotation, as these photographs, reinforced what the association was trying to promote—Lake Bluff, a beautiful and restful natural environment to visit.

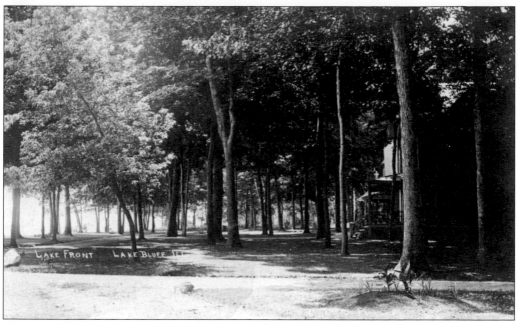

These cards show Lake Front Park looking north from Park Avenue to Ravine Avenue. It was at this park that the Lake Bluff Camp Meeting Association built the village's first gazebo, where numerous band concerts were presented during the 1890s up to World War I. To celebrate the nation's bicentennial in 1976, the village erected a replica of this original camp meeting gazebo. The new gazebo stands on the village green across from the village hall.

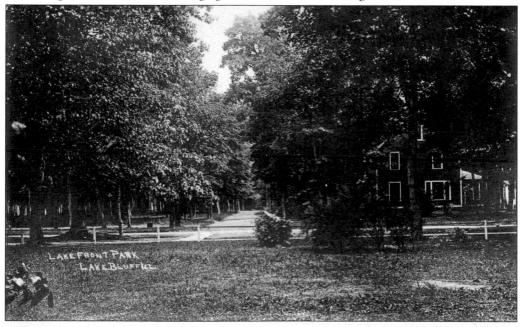

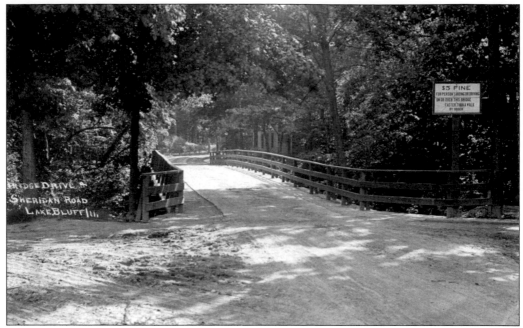

This was the first wooden bridge erected over the ravine on Harris (now Moffett) Road between Sylvan Road and Ravine Avenue. In 1914, Capt. William Moffett, later Admiral Moffett, was appointed the commandant of the Great Lakes Naval Training Station. He noticed the deteriorating old bridge every day when he drove from his home in Lake Forest to the naval base. As a result, Captain Moffett brought his naval engineers in and within 24 hours built a new steel bridge. Moffett Road is named for him.

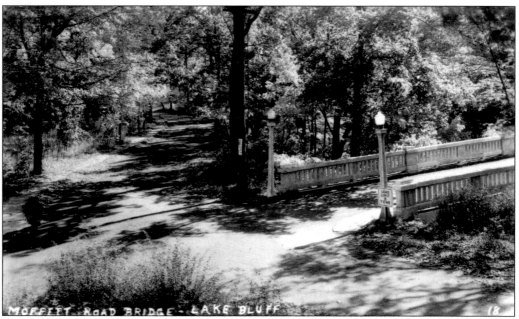

In later years, the wooden bridge was replaced by this substantial concrete structure between Sylvan Road and Ravine Avenue.

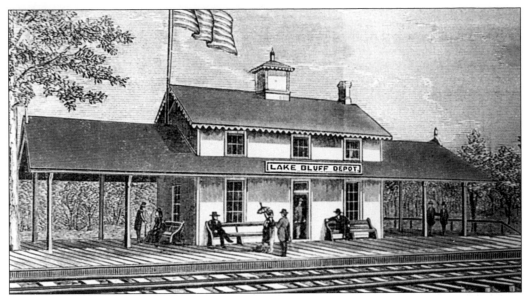

This is an illustration of the Lake Bluff train depot that was located at the end of East Sheridan Place and Moffett Road. The picture was found in the "1877 Second Lake Bluff Camp Meeting Annual." The depot benefited the summer visitors on their way to the hotels and was the last stop on a spur line from the main north–south train tracks. The spur line lasted only a few short years. By the mid-1880s, this train depot had been turned into the Sheridan Inn, a popular hotel of the period.

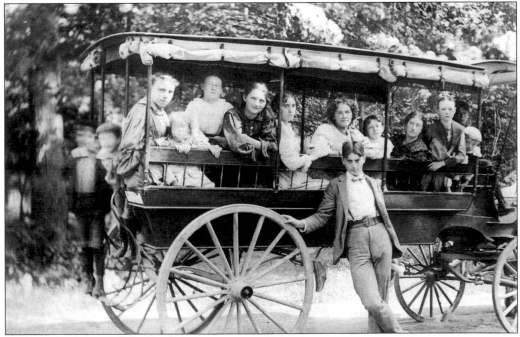

This photograph shows Gus Cloes with several admiring young ladies. Gus, the grandson of Lake Bluff's first settlers, John and Catherine Cloes, is standing in front of the "Benida," the local taxi operated by his parents, Ben and Ida Cloes. John Cloes had gone off in the 1850 California Gold Rush, never to return, leaving his wife to raise their seven children.

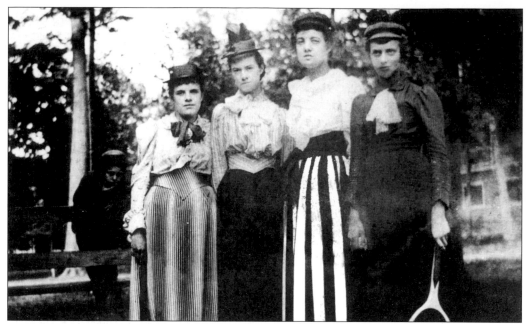

Tennis was also a sport of the young ladies of the era, one of the few competitive sports open to them. This photograph shows Grace Cloes on the right, granddaughter of the first settlers, John and Catherine Cloes, along with Ella Waidner, daughter of one of the summer resort families, Fannie Fowler, daughter of Sheridan Inn owner Laura Fowler, and Lucy Cochran.

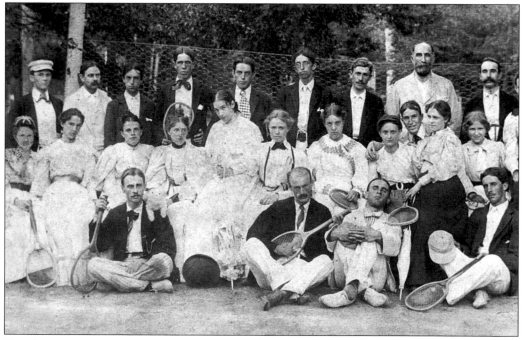

Tennis was a very popular summer pastime during the 1890s. Lake Bluff became known for its annual summer tennis tournaments, which attracted many visitors to the hotly contested events. This photograph, taken after one of the tournaments, shows local tennis players and members of their attentive audience.

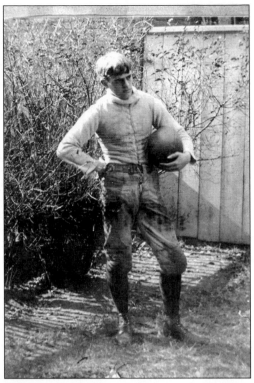

Here, pictured in his football glory, is Frank Waidner. His family summered in Lake Bluff for years at their cottage, which still stands today at 345 Sylvan Road. The Waidner family owned a very successful photography studio in Chicago. The local Kelly Klub included as members Frank and Will Waidner and John Cole Jr. The clubhouse was behind Cole's house on North Avenue. It was the Kelly Klub that organized the first Pink Rabbit Ball. Members sent anonymous and eagerly awaited invitations to their chosen young ladies. Not until the big night would a girl know who her escort was.

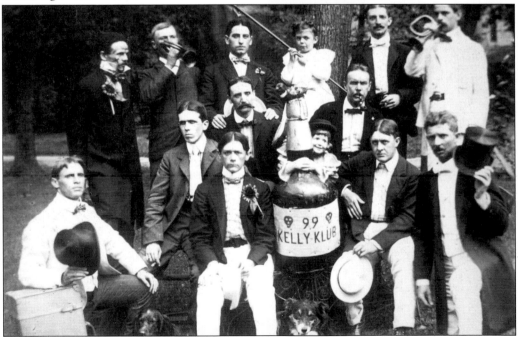

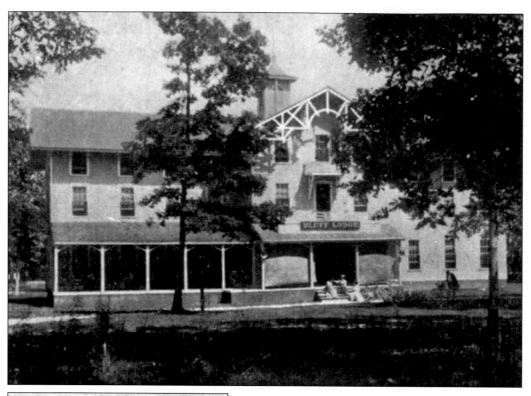

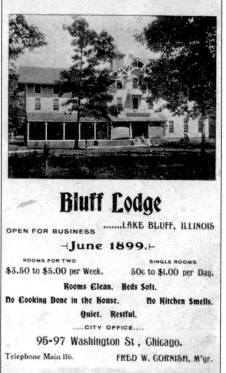

Bluff Lodge

.......LAKE BLUFF, ILLINOIS

OPEN FOR BUSINESS

-⁕June 1899.⁕-

ROOMS FOR TWO

$3.50 to $5.00 per Week.

SINGLE ROOMS

50c to $1.00 per Day.

Rooms Clean. Beds Soft.

No Cooking Done in the House. No Kitchen Smells.

Quiet. Restful.

....CITY OFFICE....

95-97 Washington St., Chicago.

Telephone Main 116. FRED W. CORNISH, M'gr.

The first hotel built for the Lake Bluff Camp Meeting visitors was the Lake Bluff Hotel, erected in 1876. It stood on the southeast corner of what is now Prospect Avenue and Moffett Road. For a time it served as an annex to the newer and larger Hotel Irving. Later it was known as the Bluff Lodge, and in 1904, it burned to the ground. The advertisement dates from the 1890s and extols the advantages of staying at the hotel where there are no kitchen smells and the beds are soft.

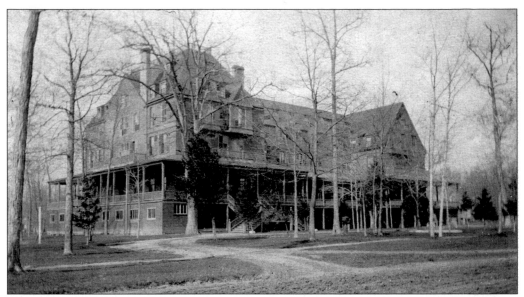

The Hotel Irving, erected in 1883, was the largest hotel between Chicago and Milwaukee and named for J. Irving Pearce, manager of the Sherman House in Chicago and also this hotel in Lake Bluff. The hotel was five stories high and accommodated 500 guests. It had shops, arcades, tennis courts, a bowling alley, and a ballroom and boasted of running water in the guest rooms. The building and grounds covered the entire 500 block of East Prospect and East Center Avenues.

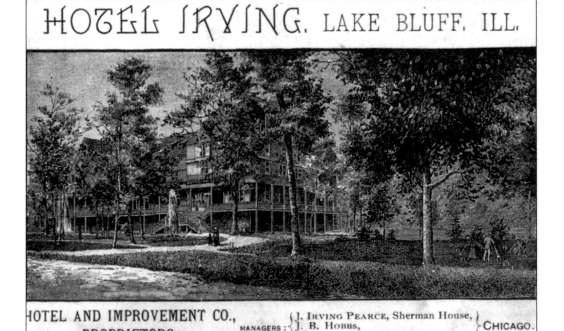

HOTEL IRVING, LAKE BLUFF, ILL.

HOTEL AND IMPROVEMENT CO.,
PROPRIETORS.

MANAGERS : { J. IRVING PEARCE, Sherman House, }
{ J. B. HOBBS, } CHICAGO.
{ C. W. LASHER. }

This advertisement dating from the 1880s includes an illustration of the Hotel Irving. Built entirely of wood, it burned in a spectacular fire in May 1897, just before the opening of the summer season. A bucket brigade of volunteers hauled water from the lake, and a pumper from the Waukegan fire department was sent by train in a futile attempt to save the hotel.

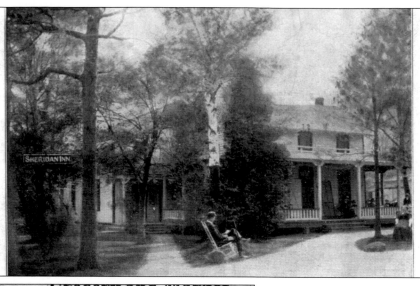

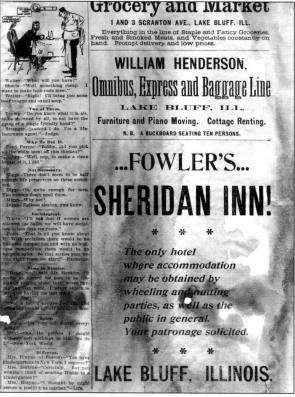
The Sheridan Inn, formerly used as
the train depot, was located on the
corner of what is now Moffett Road
and East Sheridan Place. The inn
was a popular eating and boarding
establishment run by the Fowler
family. Originally called Fowler's
Inn, the name was changed to the
Sheridan Inn in 1899 when Harris
Avenue was changed to Sheridan
Road, later to be called Moffett
Road. The Sheridan Inn outlasted
the camp meeting era and existed
until the beginning of World War I.
Left derelict for years, it burned
in 1926.

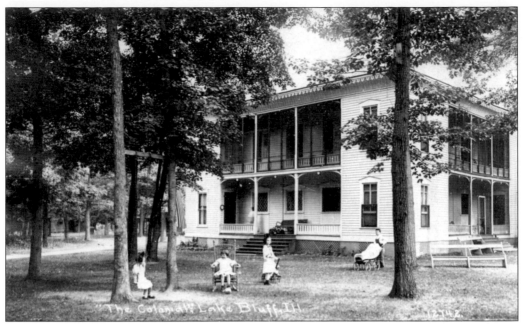

The two-story Colonial Hotel was built around 1880 and was located on Sylvan Road midway between Gurney and Glen Avenues. It overlooked the ravine and was distinguished by its prominent sleeping porches. Sarah Wheeler, the proprietor, was a staunch believer in the temperance movement. Her summer residence, Grace Cottage, was located next to the hotel. It was at this cottage that temperance leaders, including Frances Willard, met in the summer of 1881 to form the national temperance organization that later became known as the Prohibition Party. This political party was instrumental in passing the 18th Amendment to the Constitution, which ushered in the era known as the Roaring Twenties. Long abandoned, the hotel was torn down in the early 1930s.

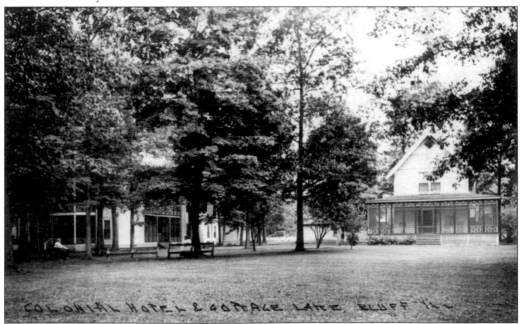

The Forest Inn was very typical of the almost 30 hotels and boardinghouses that catered to summer visitors during the camp meeting days and Lake Bluff's heyday as a summer resort. It was located on the southwest corner of Moffett Road and Scranton Avenue.

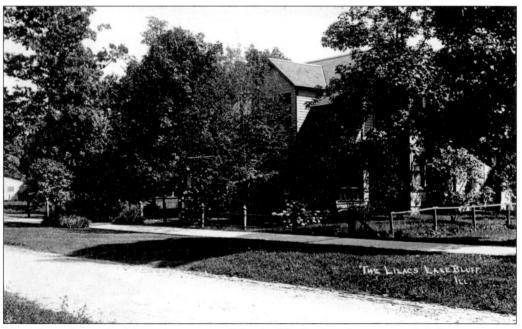

The Lilacs, shown in this card, was named for the lilac bushes that surrounded the property. A boardinghouse, eatery, and laundry, it served Lake Bluff's summer clientele up to World War I. It later became a year-round residence and still stands on the southeast corner Center Avenue and Glen Avenue.

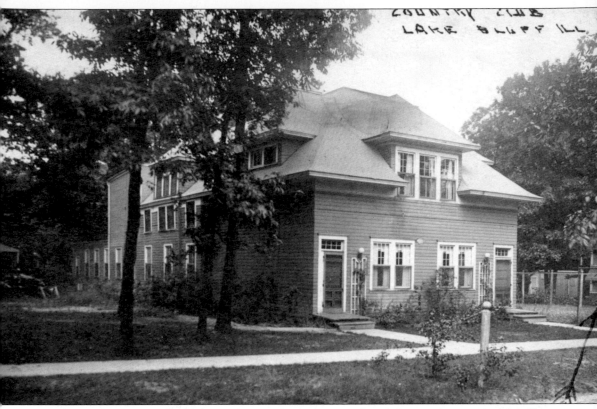

The Lake Bluff Country Club on the northeast corner of East Center Avenue and Moffett Road was built in 1897 by a group of summer residents who were upset at losing their bowling alley and meeting place when the Hotel Irving burned. The club building had two bowling alleys on the first floor with a ballroom on the second floor that could be used for performances showcasing local theatrical talent. In 1913, a minstrel show was staged at the club assisted by Con T. Murphy, a veteran actor who had performed with John Wilkes Booth in Civil War days. Until his dying day, Murphy blamed himself for Abraham Lincoln's assassination because, after hearing the threat and thinking it was not genuine, he never told anyone about Booth's plan to kill the president. The club hosted school graduations and plays. Interest in the club was dwindling in the late 1920s, and at the end of the 1928 season, it closed its doors forever. It was torn down, and the property was sold in the early 1930s.

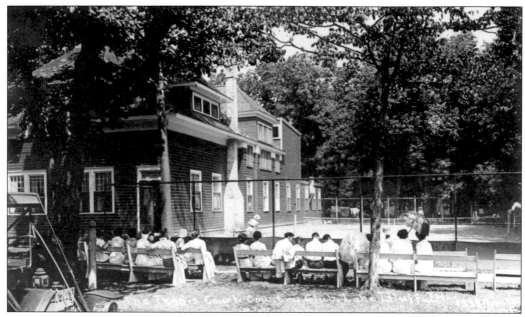

This early-1900s card shows a tournament in play on the country club's tennis courts. Although the clubhouse was not heated and was only open from April through October, it soon became the center of the village's social life.

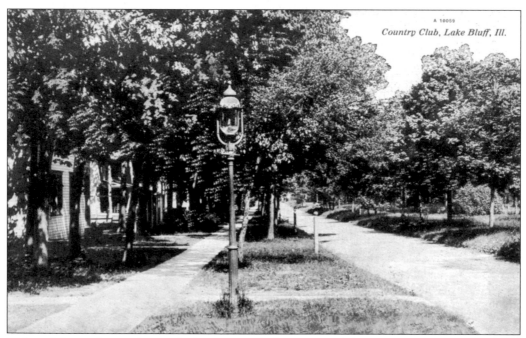

This card shows Center Avenue looking east with the country club on the left. The gas streetlamp was one of the first put in by the newly incorporated village. The old Lake Bluff Camp Meeting oil lamps were replaced in 1900, and the village lamplighter no longer made his rounds at dusk and midnight to turn them on and off.

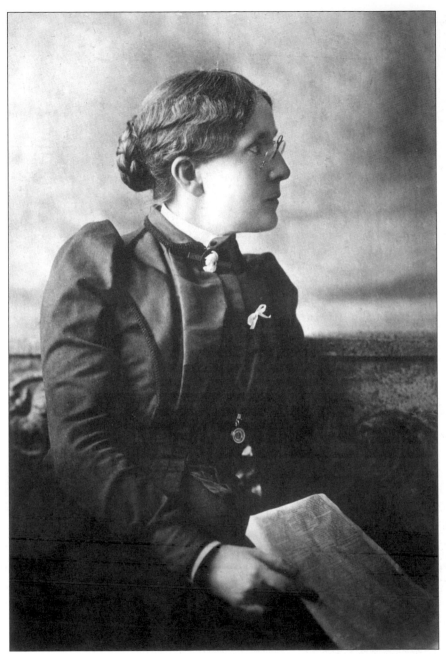

Frances Willard, the most prominent leader of the temperance movement, summered in a cottage on Scranton Avenue. She brought prohibitionists from all around the country to the Lake Bluff Camp Meetings in her efforts to rally the nation to outlaw the "Demon Rum." Willard was a childhood friend of the wife of Solomon Thatcher, founder of the camp meeting. Invited to speak at the chautauqua sessions in Lake Bluff, she proved to be a powerful speaker. Willard was elected executive secretary of the Women's Christian Temperance Union in 1875 and was instrumental in founding the Home Protection Party that later developed into the Prohibition Party. In her autobiography, she wrote of Lake Bluff as a beautiful spot on the shores of Lake Michigan and the chief rallying place of the Prohibition army.

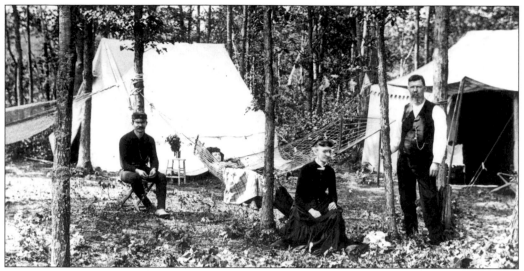

Summer campers on the bluff overlooking the lake were a common sight during the 1880s and 1890s. Few cottages were built in the Lake Bluff Camp Meeting's first years, but campers could rent tents, bedding, and kitchen utensils for a nominal sum. The Lake Bluff Camp Meeting Association had several hundred tents along with 700 cots. Campers could take their meals at the Lake Bluff Hotel, the first hotel built for the resort. The hotel's dining room had seating for 300 and charged $1 a day for three meals. Many visitors opted for these arrangements rather than stay in the hotels and boardinghouses.

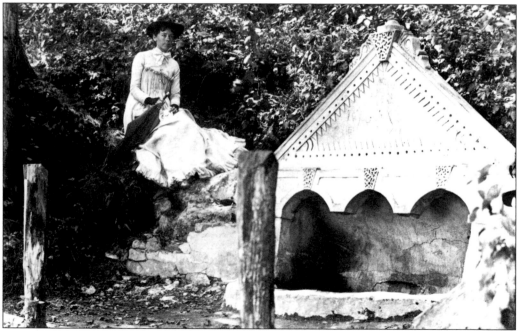

This photograph shows a young woman sitting on a log by Solomon's Pool, a mineral spring that was said to have strong medicinal properties. It was located halfway down the path to the beach near Scranton Avenue and named for Solomon Thatcher, the founder of the Lake Bluff Camp Meeting Association. An ornate concrete basin was built around it, and the spot remained a popular scenic landmark long after the spring had dried up.

Well-known and famous people of the period were attracted to the resort during the heyday of the Lake Bluff Chautauqua. Many stayed at the Hotel Irving with its comfortable appointments. Among them was Lucy Hayes, wife of the 19th president of the United States. A fervent temperance believer, Hayes came to Lake Bluff as a summer visitor to attend the numerous temperance sessions and political discussions. She was nicknamed "Lemonade Lucy," affectionately by some and derisively by others, because she allowed nothing stronger than lemonade at White House functions. It is said that while she stayed at the Lake Bluff Camp Meeting, her husband, the president, visited in Lake Forest as that community held his more liberal views on alcohol as a social drink.

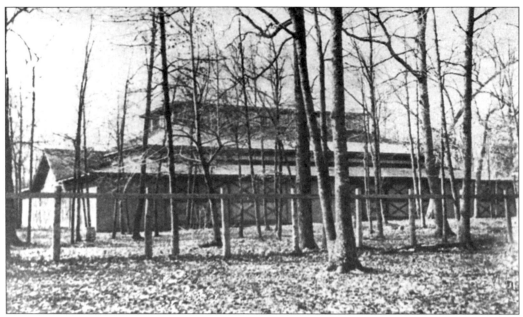

The tabernacle was a great assembly hall used for large convocations and meetings during the Lake Bluff Camp Meeting era. It had been a large tent originally but was replaced in 1883 by a wooden structure that is said to have held up to 2,500 people. Huge doors opened for the overflow crowds and also caught the cooling breezes off the nearby lake. It stood on Prospect Avenue across from the Hotel Irving on what are now the grounds of the Union Church. The picture below shows one of the Sunday school classes standing outside the tabernacle beside its open doors. In 1899, shortly after the Lake Bluff Camp Meeting Association had disbanded, the tabernacle was torn down and rebuilt as a barn and livery stable behind 500 North Avenue, where it stood for many years.

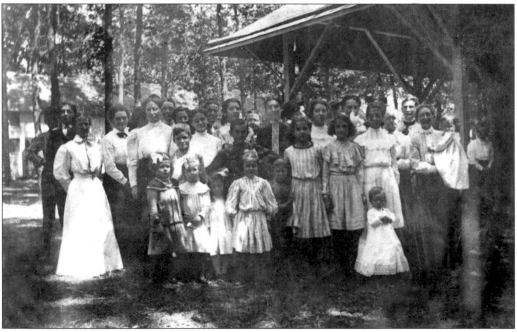

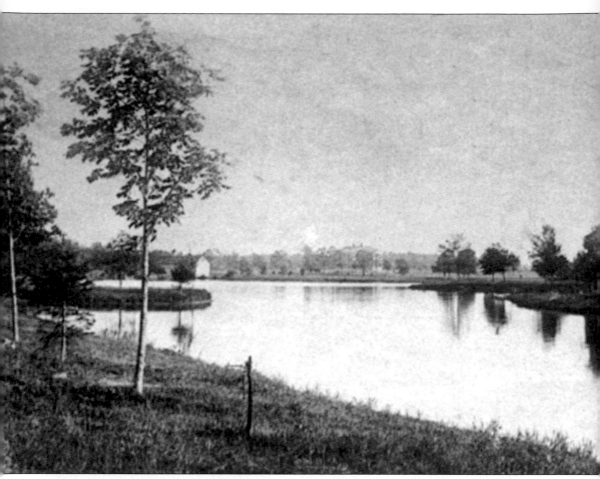

A deep artesian well was drilled in 1883 at the same time the Hotel Irving and the tabernacle were being built. The well was surrounded by a concrete dam to create Artesian Lake, which occupied nearly 10 acres between the East Elementary School and the present village hall. Swan Island was a higher area of ground, accessible by a footbridge just west of the dam. The island and lake were popular spots for summer picnicking, fishing, and boating. The lake provided a place for ice-skating in the winter, and during the winter months ice blocks were cut and stored in an icehouse for summer use. The lake was drained in 1904.

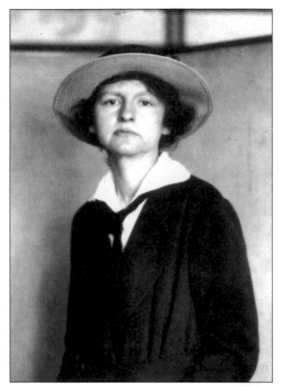

Just prior to World War I, a group of artists, writers, and others with a more bohemian bent were attracted to the beauty and quiet of Lake Bluff. They congregated near the lake on Simpson Avenue and Park Place. Among those was Alice Corbin Henderson, coeditor of *Poetry* magazine (still in existence today). She lived on Park Place with her husband, William, an artist associated with the Art Institute of Chicago.

Joyce Kilmer, the poet, spent one summer visiting the Hendersons, and local lore suggests that Lake Bluff provided the inspiration for his famous poem "Trees."

Margaret Anderson, the editor of the literary magazine *Little Review*, rented a cottage near Sunrise Avenue and Park Place. Anderson scandalized the neighbors by wearing trousers and smoking in public, unheard of for a woman at that time.

Joe Howard, a well-known songwriter in the period before World War I, wrote, "I Wonder Who's Kissing Her Now," the most popular song of 1914. While living in Lake Bluff, Howard was the manager of the Barrison Theater, named for his wife, Mabel Barrison, a popular entertainer in musical and vaudeville shows. He is credited with giving a young violinist from Waukegan, Benny Kubalsky, his first start in show business playing in the Barrison Theater's shows. This young performer later earned fame as comedian Jack Benny.

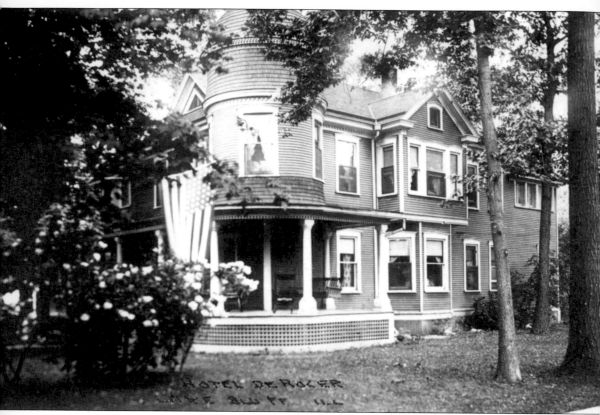

The Hotel DeRogers, a wonderful example of Queen Anne architecture, was the last of the Lake Bluff Camp Meeting–era hotels to be torn down. Located on the southeast corner of Prospect and Glen Avenues, it was demolished in 1937. Those who grew up in the village during the 1920s and 1930s remember the old building. They had fun playing around the old wooden water tower that once was a part of the Hotel Irving and exploring the ruins of abandoned summer cottages scattered around the town. The Hotel DeRogers was the last visible sign of the old Lake Bluff Camp Meeting, and its demolition signaled the end of a gentler time. When it succumbed to the wrecking ball, the country was on the brink of another world war, and the ideals and beliefs that had held such promise half a century before seemed inconsequential.

Two

A SOCIAL
RESPONSIBILITY

The Industrial Revolution brought many positive changes to American life in the last half of the 19th century. It also brought about numerous social and economic ills to those least able to deal with adversity. Awareness by those more fortunate that society had a responsibility to provide assistance to the underprivileged brought to Lake Bluff several long-lasting institutions whose purpose was to alleviate some of these social problems.

The largest of these was the Methodist Deaconess Orphanage, founded in 1894, when six young children were rescued off the streets of Chicago and housed in a small cottage in the village. In 1895, James Hobbs, president of the Lake Bluff Camp Meeting Association, donated funds to erect a new building for the orphanage. Originally known as the Lake Bluff Orphanage, it would eventually house up to 200 children in the seven buildings located on Scranton and North Avenues between Evanston and Glen Avenues. It closed in the late 1960s, and the buildings were demolished in 1979.

Marshall Field and Company purchased a large summer cottage on Foss Court to provide its employees an opportunity to enjoy the beauty of the village and provide them a respite from the dirt and grime of Chicago.

A small cottagelike hotel for single workingwomen from the city, called the Working Women's Home, was designed by the noted architectural firm of Adler and Sullivan. Later known as the Hotel Minnetonka, it burned to the ground in 1917.

The Gads Hill Social Settlement, a neighborhood center in Chicago, opened a summer camp in Glencoe to provide a restful place for mothers and their children to escape from the tenements of the city. It purchased 23 acres of lakefront land in Lake Bluff in 1907, enabling it to serve even more of these families. The Arden Shore Association acquired the camp in 1912. Its mission changed in the 1930s when more substantial buildings were erected to house homeless and neglected boys who would live year-round to experience an improved educational and recreational environment. Arden Shore remained in Lake Bluff until the late 1990s when it relocated and sold its very valuable lake property.

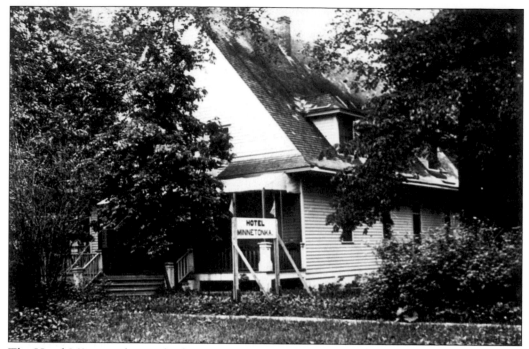

The Hotel Minnetonka was built in 1894 by the Working Women's Home Association for the free accommodation of workingwomen from Chicago. The modest cottage was designed by the well-known Chicago architectural firm of Adler and Sullivan. It was located on the northwest corner of North Avenue and Maple Avenue near a narrow carriageway that led to the beach. It was later described as the "Honeymoon Hotel" for its proximity to this moonlit path to the lake. The hotel burned in a spectacular fire in 1917, shown below. The volunteer fire department used the village's first motorized fire engine to fight the blaze, but the hotel was a total loss.

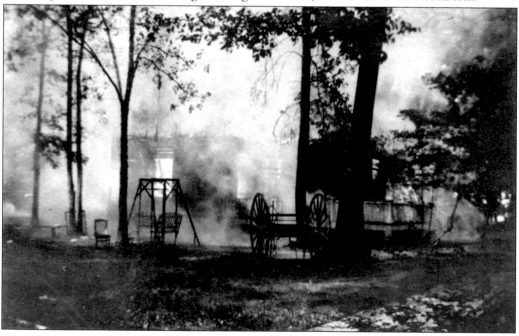

James Hobbs was president of the Lake Bluff Camp Meeting Association, a past president of the Chicago Board of Trade, and a successful real estate entrepreneur with offices in Chicago and Lake Bluff. Hobbs was instrumental in the founding of the Methodist Deaconess Orphanage in 1894 when six homeless children were rescued from the streets of Chicago and brought to a rented cottage in Lake Bluff. His wife, Marilla, persuaded him to provide funds to build a permanent building for the orphans. Marilla was an ardent supporter of the Women's Christian Temperance Union and is shown here in front of Frances Willard. By 1900, the entire block of Scranton and North Avenues between Evanston and Glen Avenues was the site for buildings that would eventually house 200 children.

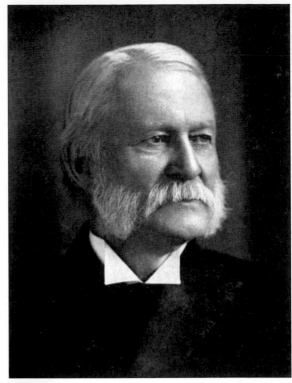

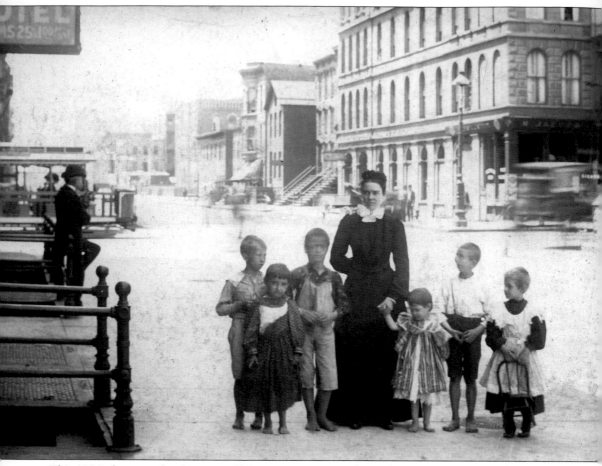

This 1894 photograph taken on a Chicago street corner shows the six children who became the first residents of the new orphanage in Lake Bluff. Homeless and hungry, these youngsters, and others who would arrive later, found a safe haven in the village.

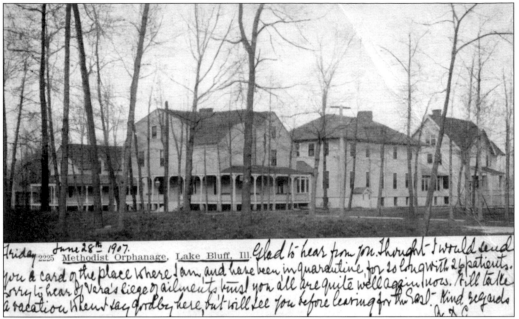

Shown here are several of the orphanage buildings looking from the southeast corner of Glen and Scranton Avenues. These buildings were constructed of wood, as was typical of the era. The orphanage included dormitories, a hospital, bakery, laundry, and school. James Hobbs continued to provide substantial funding in memory of his wife after her death. These funds helped offset the cost of the construction needed to house an increasing number of children, and one of the new structures was named the James B. Hobbs Building. Funds raised through voluntary contributions supported the orphanage general fund.

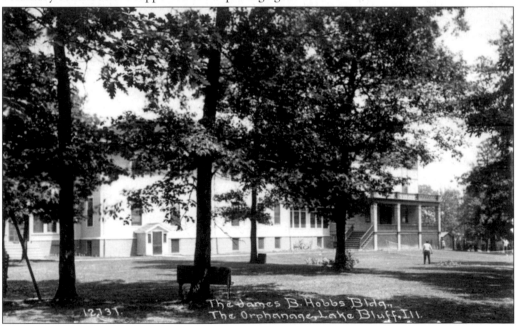

The James B. Hobbs Bldg., The Orphanage, Lake Bluff, Ill.

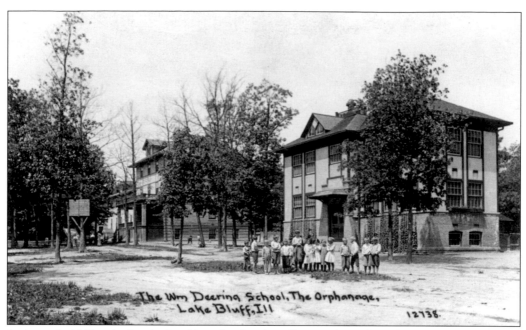

In the early 1900s, the local school board refused to allow students from the orphanage to attend the Lake Bluff public school due to the fear of spreading disease. William Deering, a Chicago philanthropist, donated money to build a school on the grounds, and the school was named in his honor. In time the orphanage students were allowed back into the public school.

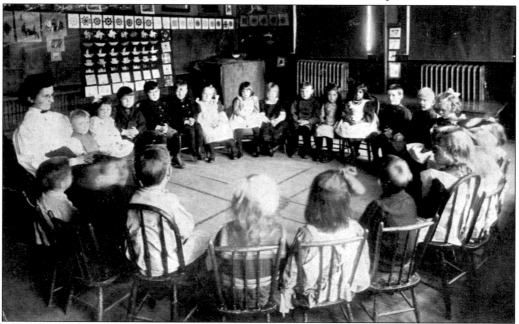

Children were schooled on the orphanage grounds from kindergarten to sixth grade. They attended the Lake Bluff public school for seventh and eighth grades. High school students were enrolled in the Deerfield Shields High School located in Highland Park, as were the other Lake Bluff children. Sewing and cooking, sometimes called domestic arts, for the girls and manual training for the boys were provided by the home.

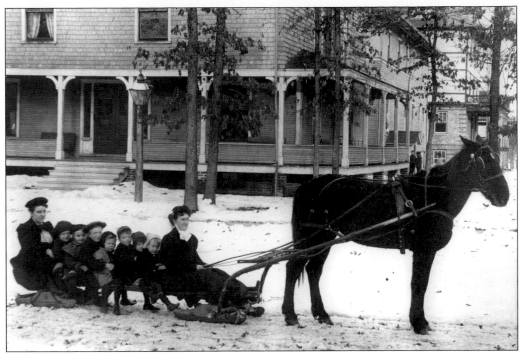

The deaconesses' goal was to provide a normal home life for their charges. Children participated in a variety of recreational activities and physical exercise on the extensive grounds of the Lake Bluff Children's Home. Sledding and sleigh rides were extremely popular during the winter season, and groups were sometimes taken on outings off the orphanage grounds. The children in the picture below, playing "Ring around the Rosie" with their housemother as part of their daily exercise program, are warmly dressed for the cold. Clothing for the children was often provided and paid for through private donations.

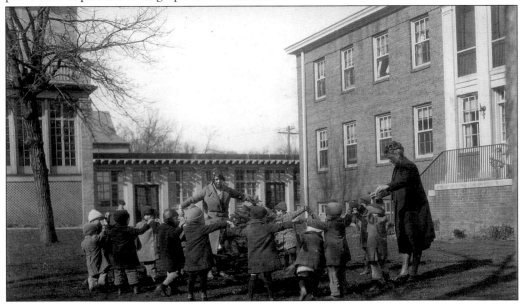

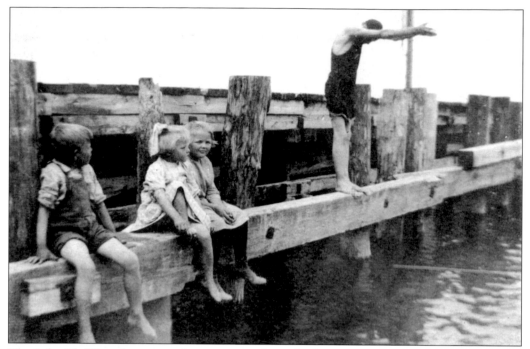

The Lake Bluff beach was a welcome retreat from the heat during the summer months. The children were taught to swim in Lake Michigan as a part of their physical education program, and they enjoyed spending many summer days diving off the old wooden pier.

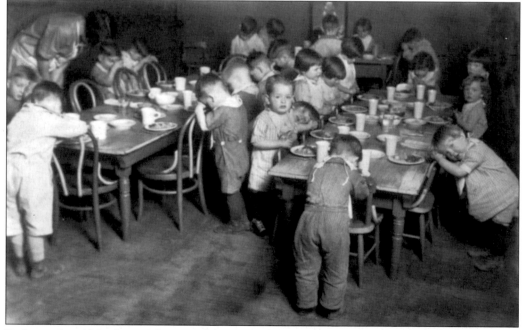

Rule number 10 in the regulations of the Methodist Deaconess Orphanage stated, "All children shall be instructed in the Holy Scriptures, and learn the Lord's prayer, the Ten Commandments, the Apostles' Creed, catechism, and such other requirements that may be considered suitable for their training."

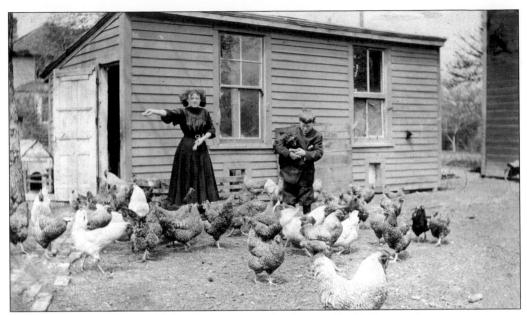

The annual report of the Methodist Deaconess Orphanage for 1901 states that support for one child was $72 per year, or $1.50 per day, or $6 per week. Keeping chickens and raising vegetables on the premises augmented the necessary grocery supplies. The boys' cottage was responsible for caring for the chickens and collecting the eggs. Both girls and boys helped to cultivate the garden and harvest the vegetables to be prepared in the orphanage's kitchen. There was also a fully equipped bakery that produced baked goods, not only for the residents but for sale to the local community at special times.

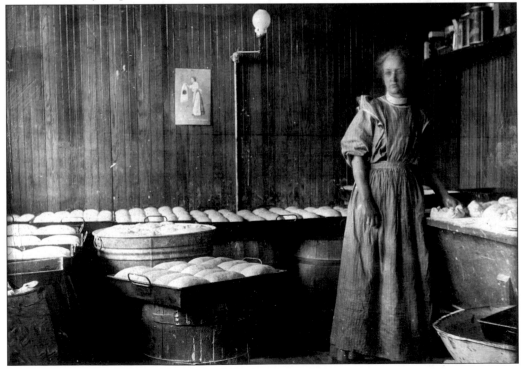

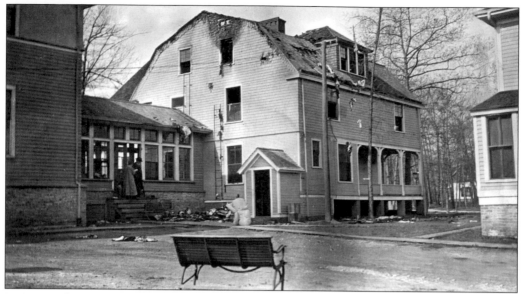

In 1911, a disastrous fire broke out in a dormitory where the younger children slept. All were rescued with the sad exception of a two-year-old child who died of smoke inhalation. The orphanage washerwoman, Kate Dyer, who lived across the street, saw the fire and raised the alarm and then ran into the burning building to help carry out the children. She was the heroine of the day, and the Chicago press and the local newspapers extolled her courage and bravery. After this terrible incident, the old wooden structures began to be replaced with fireproof brick buildings.

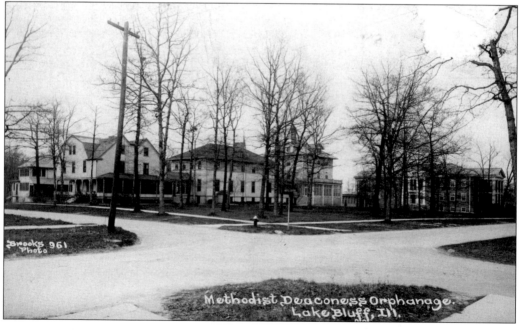

The Methodist Deaconess Orphanage received many infants, and a major mission of the institution was finding adoptive homes. A large section of the building was set aside for baby care, known as the Baby Fold, where the young charges were lovingly tended. These babies were usually readily adopted. In an annual superintendent's report it was stated that "our Baby Fold leads us in our aim to start the child in perfect health . . . and upon proper food and care in infancy, more than any other factor, depends the life of the child, and the future of the race."

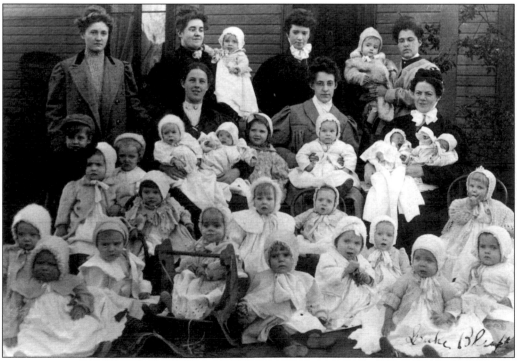

Lucy J. Judson became the first resident superintendent of the institution in January 1898 and served until 1924. Many of the children residing at the orphanage had at least one living parent who, for one reason or another, could not properly care for a family. However, many of these parents still tried to maintain contact with their children and provide for them as best they could. Parents were charged $2 per week or $8 a month for support, if they were able to do so. The letter below to Judson is a poignant example.

Chicago Deaconess Home
22 West Erie Street

MR. J. R. HOBBS, PRES. BOARD OF TRUSTEES
MRS. A. H. ANDREWS, TREASURER
IDA A. JORDAN, SUPERINTENDENT AND
ASS'T TREASURER

Phone North 959

Chicago, May 13th 1915

Dear Miss Judson
 Here
is two dollars for the
shoes Mary needs —
Her Mother just
brought it and is
waiting to mail this
letter — Sincerely
 Minnie Stillmarth

One of the children at the orphanage was Raymond Moore. His mother brought him to Lake Bluff around 1900 as a young child. Later Raymond's mother asked that he be sent home from the orphanage as she felt she could again care for him. However, Raymond preferred living at the Lake Bluff Children's Home and in a short time arrived back in Lake Bluff by train, staying at the orphanage through high school. He attended college and became an educator. When Lake Forest High School was built in 1935, Raymond Moore was appointed as administrator and its first principal. He remained in that position for many years, and his service to the school was honored when the school auditorium was named for him.

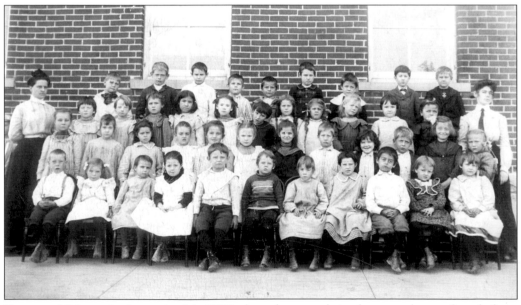

Raymond Moore is shown in this 1902 class photograph in the second row, fourth from the right.

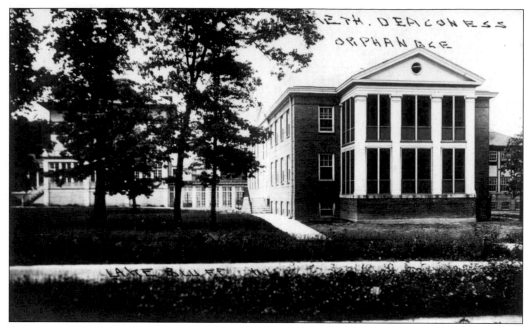

In the late 1930s, two Georgian brick dormitories were built, almost identical in style. The girls' dormitory was named the Whipple-Judson Hall and the boys' dormitory was called the Wadworth Hall. With the exception of the small infants who were cared for elsewhere, all the children in the orphanage were house in these two structures. This is the Whipple-Judson Hall.

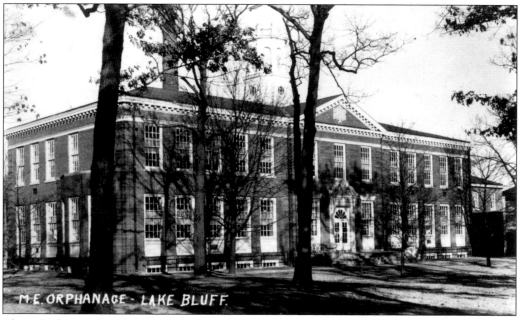

Above is the Mackey Administrative Building.

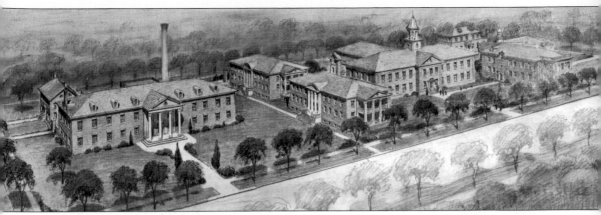

An aerial view of the Lake Bluff Children's Home shows the Wesley Dining Hall, Whipple-Judson Hall, Wadworth Hall, and Swift Hospital. These substantial buildings would be used until the Lake Bluff Children's Home closed its doors in the early 1970s. In 1979, unable to sell the buildings, they were torn down and the property sold to a developer.

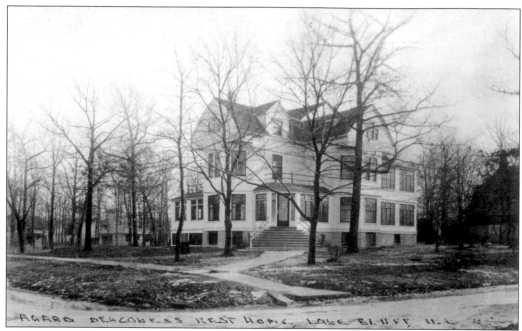

The Agard Deaconess Rest Home located on the southeast corner of Glen and Scranton Avenues was a retirement home for Methodist deaconesses who had served the church in a variety of ways, including nursing and mission work. It was also used as a temporary rest home for Methodist ministers. It was formerly the home of Rosa West, a director of the Lake Bluff School; she donated it to the Methodist Church in 1895 and named it for her father, a Methodist minister. It remained in use as a rest home until 1955 and was demolished in 1960.

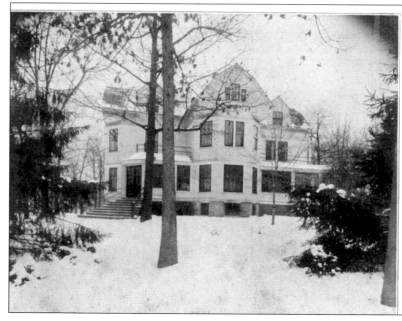

The Agard
Deaconess
Rest Home
Lake Bluff
Illinois

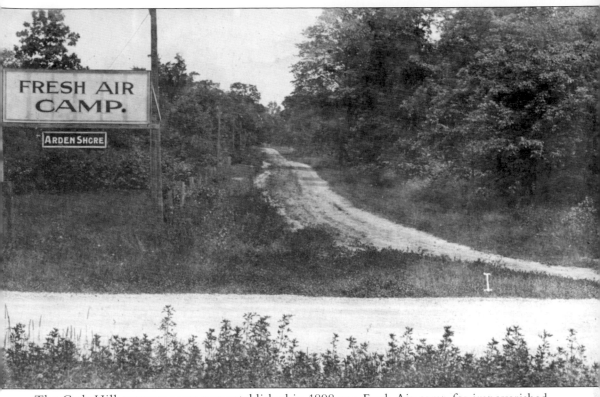

The Gads Hill summer camp was established in 1898 as a Fresh Air camp for impoverished mothers and their children from Chicago. They were to spend a week enjoying the breezes off Lake Michigan.

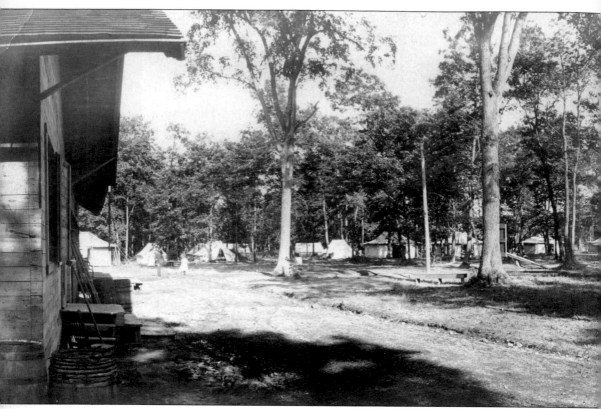

Gads Hill was first established as a Fresh Air camp in 1898 near the suburb of Glencoe for underprivileged mothers and their children to allow them to come up from Chicago and spend a week enjoying the breezes off Lake Michigan and relaxation from their usual lifestyle. In

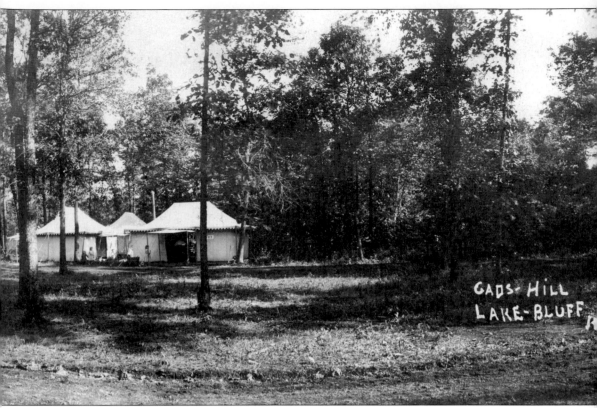

1907, 23 acres were purchased along the lakefront just north of Lake Bluff, and Gads Hill was reestablished at that site. The camp was sponsored by prosperous businessmen and their wives from Chicago. In 1912, the name was changed to Arden Shore.

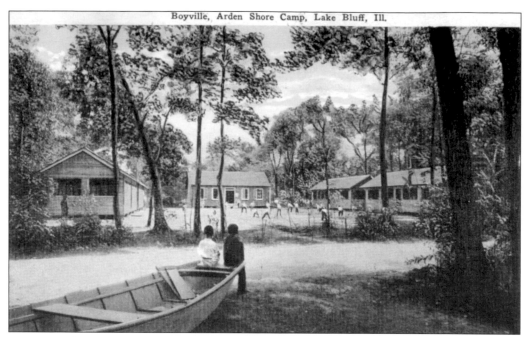

Boyville, Arden Shore Camp, Lake Bluff, Ill.

In 1912, Arden Shore began serving undernourished children. The Chicago Board of Education sent boys between the ages of 14 and 17 to stay from October to May. The concept was to build them up physically and mentally to become better qualified to enter the working world. The summer months from June through September allowed mothers and their children, as well as adolescent working girls, to enjoy outings at the site. The tents gave way to sturdy wooden structures spread out on the 22-acre campus. Arden Shore was totally financed by private donations and benefits held by communities on the North Shore.

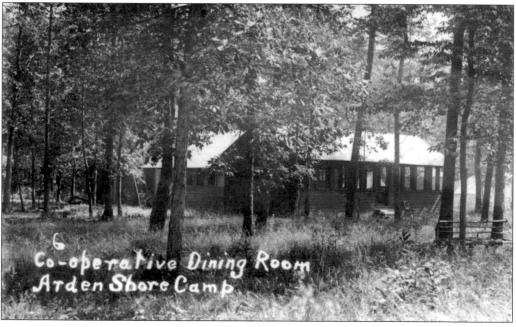

Co-operative Dining Room
Arden Shore Camp

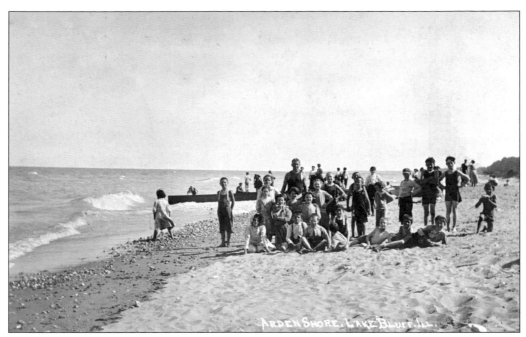

In the 1915 report of the Arden Shore Association, the superintendent states, "Arden Shore gives new direction to thought, new love for the things outdoors, new impetus to right living, and a new courage to face life's problems." Emphasis was put on wholesome food and personal hygiene. Arden Shore also stressed that one of its main goals was social gain for all its campers.

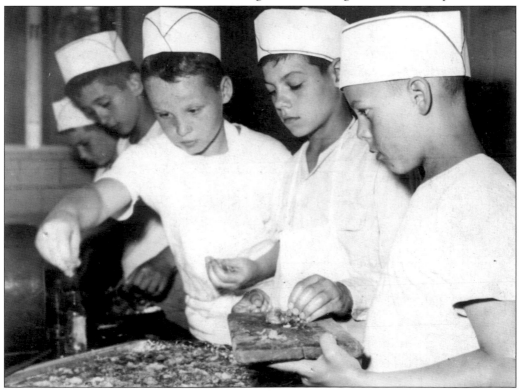

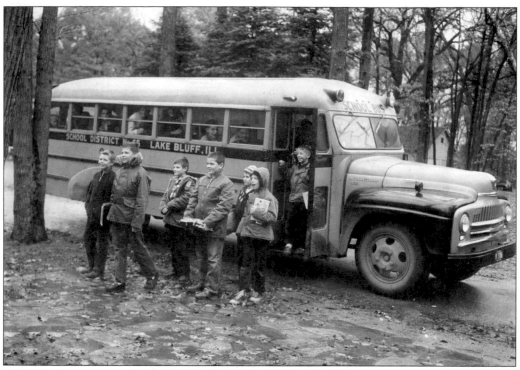

A 1954 newspaper article cites Arden Shore as the only school in Illinois offering special care for dependent boys with superior capabilities. Boys between the ages of 6 and 12 were eligible for placement. They attended the Lake Bluff elementary schools and Lake Forest High School. Their program of after-school, weekend, and holiday activities included photography, woodwork, ceramics, painting, swimming, and scouting. Special facilities were built to permit the boys to do research and experiment in the arts, sciences, and humanities.

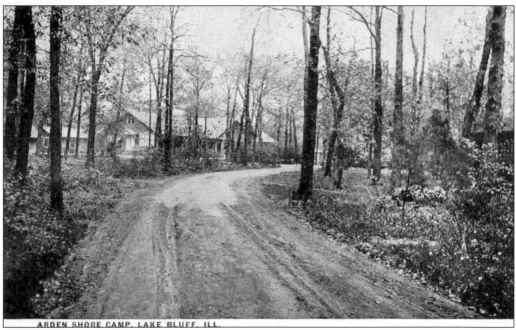

ARDEN SHORE CAMP, LAKE BLUFF, ILL.

The Great Depression altered the way Arden Shore defined its mission. The agency then aimed its services exclusively to homeless, dependent, and neglected children in an effort to reduce delinquency among youth. By 1950, new permanent buildings were erected and the focus changed again to target gifted boys with behavior problems or family difficulties. Arden Shore sold its lakefront property in Lake Bluff in the 1990s and developed group homes around Lake County.

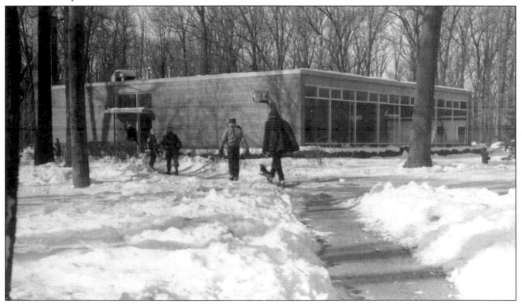

In 2006, when the administration building at Arden Shore was finally demolished, a workman found some photographs hanging on a wall in the soon-to-be-torn-down building. This was one of them. Dating from the mid-1950s, it was simply labeled "Arden Shore Boys" with the names printed on the photograph. From left to right are Thomas Sneed, Roy Sanchis, Douglas Gregory, Jay McCloskey, and Eric Pytlik. It is a final reminder of a 100-year-old presence of the Arden Shore Home for Boys.

Three

COTTAGES AND ESTATES

Of all the suburbs that hug the shoreline north of Chicago, Lake Bluff is considered by many to be the most picturesque and quaint. Nestled among the tree-lined streets and meandering ravines, it retains the vestiges of a time when the village was one of the most popular 19th-century summer resorts in the Midwest. The contour of Lake Bluff Camp Meeting cottages can still be seen in some of the current homes.

The first settlers' homes were log cabins while later structures were built of clapboard. The oldest existing home in Lake Bluff was erected for use as a boardinghouse and tavern in 1855 when the railroad track was laid. It still exists as a private residence on Mawman Avenue. The Lake Bluff Camp Meeting Association offered summer cottages for $250 to be built in 20 days. These were similar in size and design to the resort cottages at Oak Bluffs on Martha's Vineyard and at Ocean Grove, New Jersey. Although most of the cottages were very modest in size, some of the summer homes were substantial dwellings.

In the early 1900s, several wealthy Chicago families constructed large mansions in the village, hiring prominent architects to design these symbols of their success. Just before World War I, new homes for the middle class were built in the village. Lake Bluff was evolving into a modern suburb of Chicago. The years of the Great Depression halted most building, and it was not until after World War II and the emerging baby boom that significant growth took place.

Today the streets of Lake Bluff reflect the varied architectural styles mirroring the history of the village through the 19th and 20th centuries. Camp meeting cottages, American foursquare, prairie style, English Tudor, and ranch homes can all be found within the boundaries of this very American town.

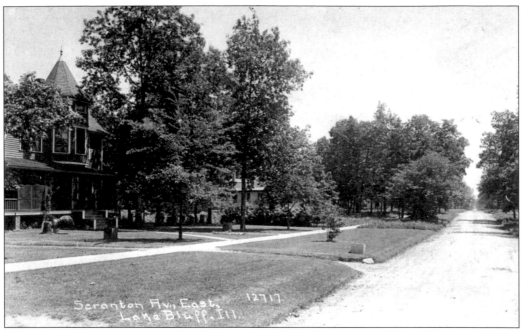

This Queen Anne home shown above stands on the northeast corner of Center and Oak Avenues; it was moved to this location from the north side of Scranton Avenue near Walnut Avenue. The postcard below shows the Scranton Avenue location. The original owner, D. Witherstine, built the house around 1900. He ran a laundry service in his home and also served as village clerk from 1897 to 1916. Witherstine lost the view to the south when the central business area grew, so he moved the house to its present location shown below.

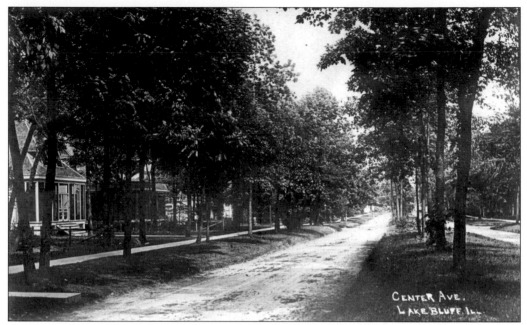

A view of Center Avenue at the beginning of the 20th century shows an unpaved street with a center dividing median. Originally named Centenary Avenue in honor of the America's centennial, it was later changed to Centre and then finally to Center. It remains the only divided street in the village.

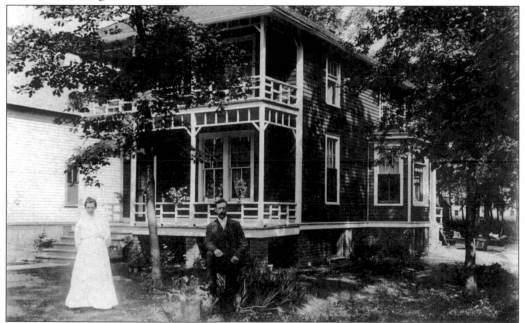

This cottage located at 210 Center Avenue was built in the late 1890s. The double front porch shown on this home was not typical of Lake Bluff's gable-front cottages. For about 40 years it was the home of Severt and Magda Moe, longtime teachers in the Lake Bluff school system. The house was demolished in 2005 and replaced with a structure that retains the unique character and many of the original features.

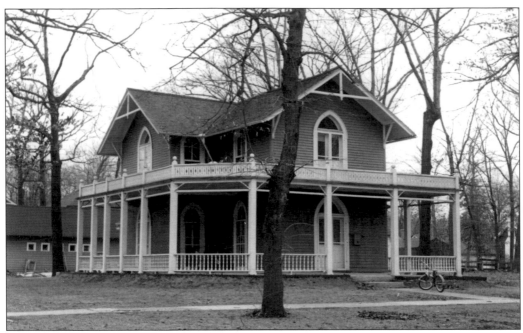

This carefully preserved Lake Bluff Camp Meeting cottage exhibits the Gothic Revival architecture that was the predominate style of early Lake Bluff. Noteworthy for its arched windows and doors, the house was built around 1890 by J. Edward Lee, one of the first village trustees. At one time there were many cottages with these characteristic features, but this one at 345 East Center Avenue is the last remaining. Alexander Jackson Dowling wrote a book in the 1850s showing examples of country cottages for the American family, and his plans greatly influenced the design of the Lake Bluff Camp Meeting cottages. These two photographs date from the late 1940s, when a small addition was built on the back and the original doorway was moved.

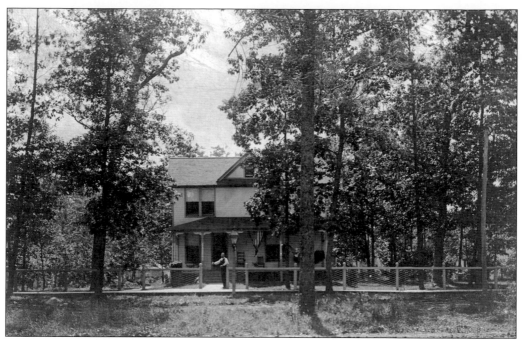

This photograph, taken in the early 1900s, shows a member of the Edward Dann family in front of their summer home on Center Avenue. Edward, born in Sheffield, England, was a banker from St. Louis. The Danns enjoyed the scenic attractions of Lake Bluff and built their home here. Originally facing north, it was turned to face west in the early 1900s, and a new addition was built on the north side. As a side note, the Danns had a son who became a clown in the Barnum and Bailey circus. The photograph below shows the home after it was turned.

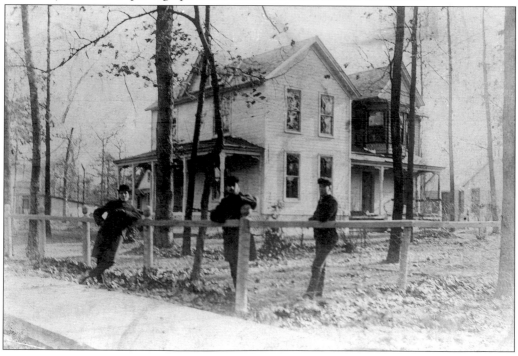

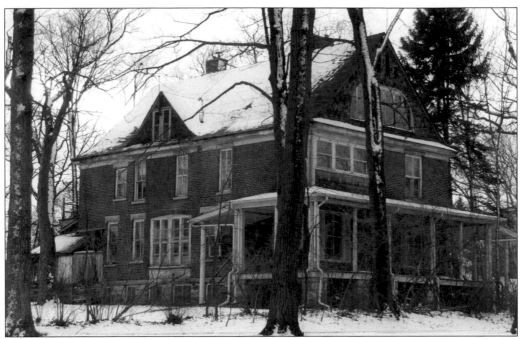

This redbrick Queen Anne home stood on the southeast corner of Center Avenue and Gurney Avenue. It was built in 1895 for Rosa West, a Lake Bluff school trustee. She was so impressed by the new brick school that had just been built on Sheridan Place that she included many of its features in the design of her home. The home was owned by the Crosby family for many years and was demolished in 2000.

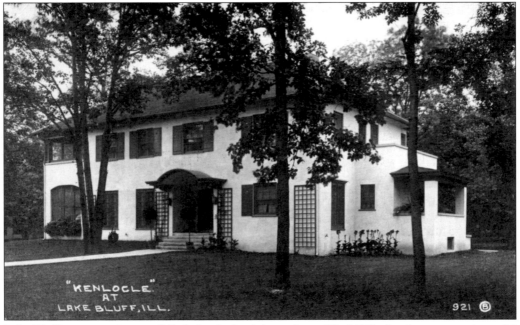

Lake Bluff was emerging as a full-fledged suburb just prior to World War I, when many substantial year-round residences were built in the village. This one, called Kenlocle, was one of three built on the 500 block of Center Avenue by friends who had been neighbors in Hyde Park.

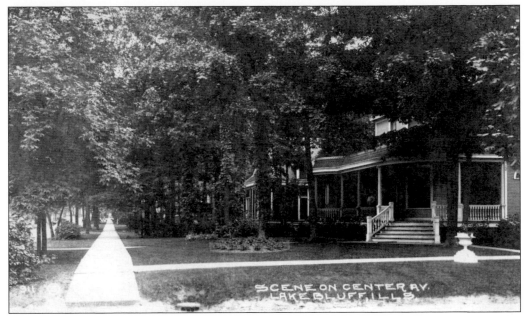

John J. Murdock, a partner with the B. J. Keith vaudeville theaters and movie houses, built this Queen Anne–style home on the northwest corner of Center and Maple Avenues around 1903. The living area was designed with a small stage for entertainment. Murdock brought the first motion pictures to the village in 1910. They were shown at the village hall, and residents paid 25¢ to see the latest silent films.

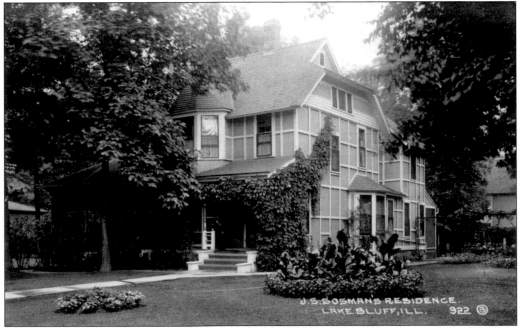

J. S. Sosman was a well-known designer and painter of theatrical scenery and curtains when he built his home in the 500 block of Center Avenue in the early 1900s. A unique feature of the house was the canvas ceiling that Sosman decorated and painted. The June 1902 issue of *Ladies Home Journal* featured an article about the home.

Horace Wright Cook was appointed village attorney in 1901 and built his home at 700 Center Avenue. His daughter, Marion Claire, was an internationally known opera singer in the late 1920s and 1930s. In 1942, she sang in the Hollywood film *Make a Wish*, starring Basil Rathbone. In 1947, she joined her husband, Henry Weber, in producing the *Chicago Theater of the Air* program on WGN radio. When Marion took ownership of the house in 1936, the well-known architect Jerome Cerny was hired to redesign and remodel the home to reflect Marion's talents and taste. The house still stands at 700 Center Avenue and is often referred to by local residents as the "Castle House."

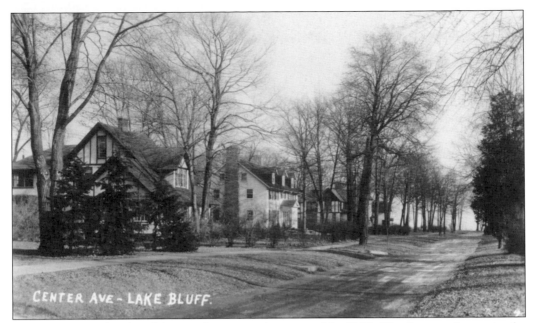

Here is the north side of Center Avenue as it appeared in 1938. The Sosman house in the foreground reflects the changes from the original home to a Tudor Revival style of architecture. In the distance is Marion Claire's home.

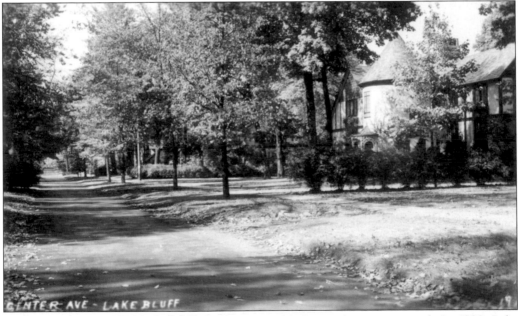

This photograph looking west near the house at 700 Center Avenue was made in 1938. Lake Bluff produced a display for the state capital in 1938 showing a "then and now" sequence of photographs illustrating the many improvements the village had implemented. This postcard was made from one of those photographs.

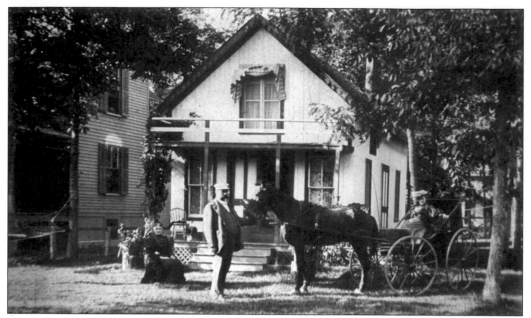

The Lake Bluff Camp Meeting was developed by a group of well-to-do Methodist laymen who broke away from the Des Plaines Camp Meeting. They wished to establish a summer resort that would appeal to the new and prosperous middle class that had emerged as a result of the industrial progress in the mid–19th century. One such family, the Allings, moved this little cottage to Lake Bluff from the Des Plaines Camp Meeting around 1900 as their summer home. The site of their cottage is now 240 East Prospect Avenue.

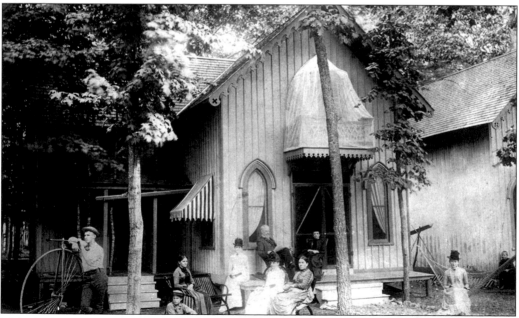

This Gothic Revival cottage looks much like cottages at Oak Bluffs on Martha's Vineyard. It was known as the Bide-a-Wee and was situated near the tabernacle on Prospect Avenue. It was an excellent example of the camp meeting cottages built in the late 1800s. Notice the mosquito netting on the upper-level sleeping porch.

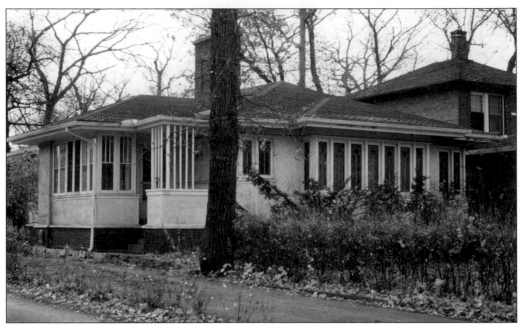

Lake Bluff boasts of two Frank Lloyd Wright homes that were built in the village. Built in 1917 at 231 East Prospect Avenue, the structure above is a prefabricated home designed by Wright and built by the American Systems Home Company. Wright's purpose in the precut endeavor was to create architect-designed homes for moderate income families. This modest one-story, two-bedroom home with Wright's distinctive windows is still a family residence. Below, the other Wright home was built in 1911 for Herbert and Mary Angster. It was located high on the bluff overlooking Lake Michigan, and when the Angsters divorced, Mary Angster retained ownership. Later she was sometimes referred to as "Crazy Mary" because of her reclusive nature. Sadly, the house burned in a spectacular fire in 1956 and the ruins were simply pushed over the bluff.

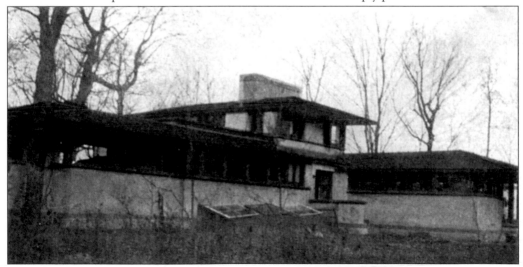

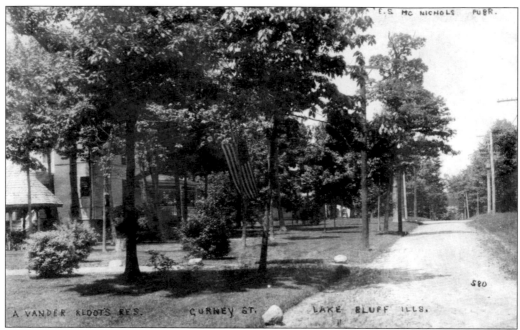

The house shown below in the 300 block of Prospect Avenue was built in 1911 by William Vanderkloot. It was originally occupied by William's father, Adrian Vanderkloot, whose earlier home pictured above had burned. After Adrian's death, William moved into the house with his family. He was owner of the Halsted Steel Works in Chicago and became village president in 1917. His son, William Jr., learned to fly and was known to "buzz" his neighbors by flying low over Prospect Avenue. In 1939, William Jr. joined the Canadian Royal Ferry Command, piloting bombers to England. In 1943, he was chosen to fly Winston Churchill on a secret mission to Moscow and was the subject of a book by Bruce West titled *The Man Who Flew Churchill.*

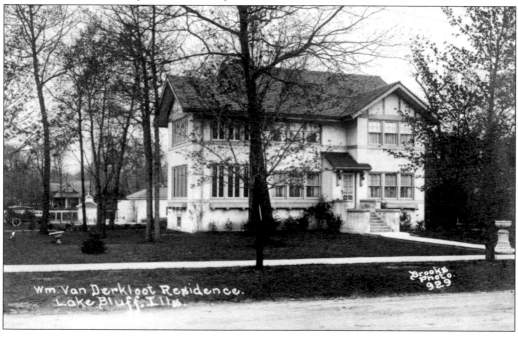

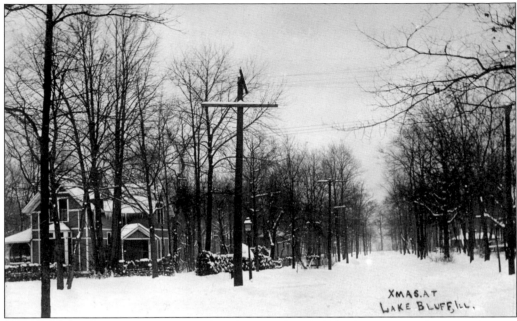

This postcard shows a snowy December day in Lake Bluff, looking east on Prospect Avenue toward the lake. The house on the corner was the home of Harry Lyon, an orchestra director who directed several musicals at the tabernacle during chautauqua days. He directed an Olde Folks Concert at Grace Church in 1914 reminiscent of one he had produced in 1895.

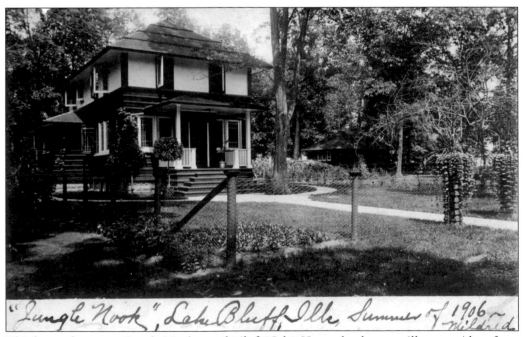

This home, known as Jungle Nook, was built for John Howard, who was village president from 1909 to 1913. Howard engaged architect Webster Tomlinson to design this prairie-style house at 710 Prospect Avenue. Tomlinson was greatly influenced by Frank Lloyd Wright and for a time was his business partner.

This view is of 10 North Avenue about 1900. Although the side porch is gone, this simple cottage still remains in its original location, virtually unchanged. The other residence seen to the left was a cottage built around the same time. It had a much more checkered existence, serving for many years as a restaurant and bar. It was torn down in the 1960s.

This residence at 210 North Avenue was built by Charles Helming in the early 1900s. When the Rosenthal and Helming's Grocery and Meat Market burned in 1902, some of the lumber salvaged from the fire was used in the construction of this house. Charles Helming was Lake Bluff fire chief from 1911 to 1947. His two daughters, Alverda and Leona, were born here and lived in this home their entire lives. Alverda died at age 98, and Leona, at this printing, just celebrated her 100th birthday.

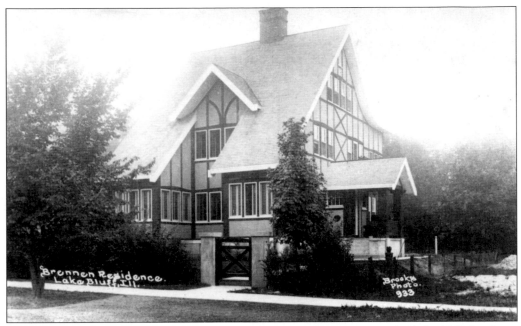

This unusual Tudor Revival–style residence at 244 North Avenue was built in 1917 for sisters Elizabeth and Lucy Brennan. There are 121 windows in the house. The sisters were members of the Theosophical Society, a religious philosophical group with mystical beliefs. The number of windows is said to have significance to the society. The house has retained most of its original features and served as a tearoom during the Great Depression.

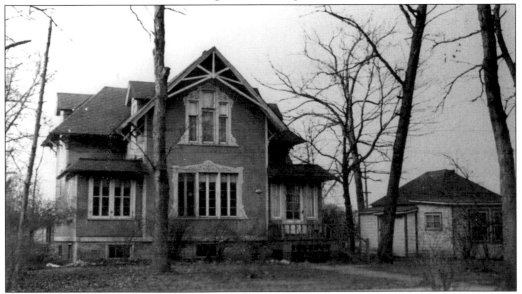

This two-story Gothic Revival cottage at 500 North Avenue was built in 1876. It served as the original office for the Lake Bluff Camp Meeting Association and was located where the present Union Church now stands. The home was moved to its present location about 1900 when the Lake Bluff Camp Meeting Association was dissolved. In its time this building hosted numerous dignitaries such as Lucy Hayes, Clara Barton, and Frances Willard. It has been well maintained as a single family home over the years.

This home, blanketed in snow, is shown in the early 1900s. It was located at 666 Maple Avenue and was built by Ben Cloes in 1886 using bricks from his family's brickyard. Cloes sold his new brick home to the Ruben Miller family. Miller was the superintendent of Judge Henry Blodgett's farm where he managed the large dairy herd on the property that was later to be known as Crab Tree Farms. This home remained in the Miller family until the 1960s when Ruben's daughter Emily died. Originally the structure was two buildings, one behind the other; later they were connected to make one home.

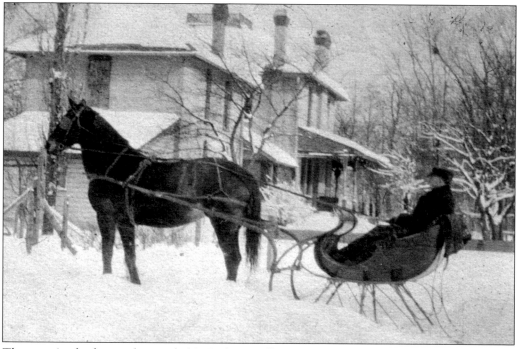

The man in the horse-drawn sled is Ruben Miller, who was one of the eight men from the village who fought for the Union in the Civil War.

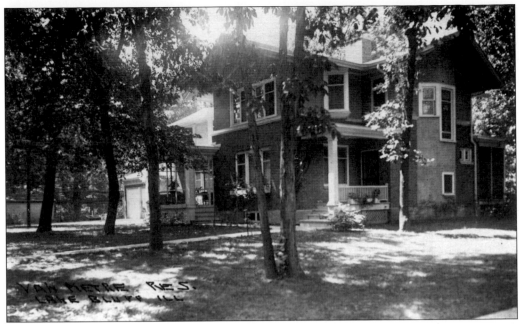

Architect Webster Tomlinson built this prairie-style home on the southwest corner of North and Maple Avenues in 1915 for the Sherman sisters, Annie and Minnie, who were professional actresses and singers. They performed at the Hotel Irving, beginning in 1894. Later, when Minnie married, a billiard room was added to the home for her husband.

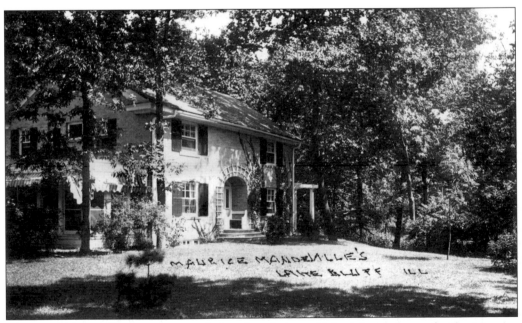

Also in 1915, Tomlinson was commissioned to design a Colonial-style home for the Maurice Mandeville family in the 600 block of Scranton Avenue. Mandeville later served as president of the school board and was very active in village affairs. Dr. John Ward purchased the residence in the 1940s to use as both his home and medical office. He lived there for over 50 years. The house was demolished in 2000, and two large new homes were built.

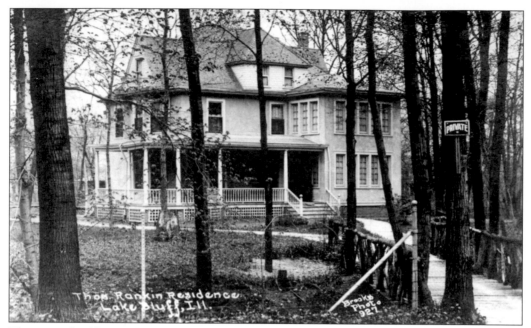

Thomas and Addie Rankin built this large home overlooking the ravine on the east side of Maple Avenue about 1900. The Rankins were active members and supporters of the Union Church, which traces its origin to the 1866 Rockland Union Church. A touring car owned by the Rankins was often used as a taxi to transport church members on various church-sponsored outings.

The residence of A. K. Stearns was north of the Rankin home on the bluff. Stearns purchased seven acres of Ben Cloes's lakefront property in 1895, tore down the old Cloes homestead, and built an impressive new home facing the lake. Stearns was the founder of the *Daily Sun*, a forerunner of the *Waukegan News-Sun*, and was elected as a state representative in 1908. When Stearns suffered financial reversals in later years, the house was abandoned, fell into ruins, and later burned.

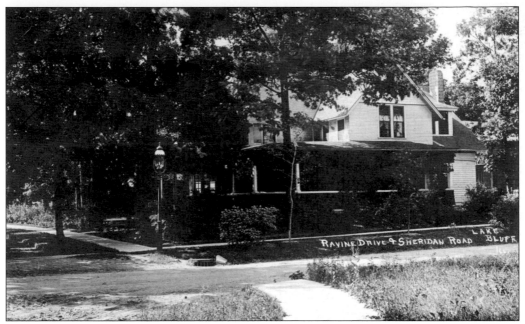

This early-1900s postcard shows the northwest corner of Ravine Avenue and Sheridan Road (later renamed Moffett Road). The house in the photograph was replaced by a new residence in 2006. The postcard below is a view looking east on Ravine Avenue toward the lake. The house on the left dates from the early Lake Bluff Camp Meeting days and is thought to have been used as an annex for the Hotel Irving during the peak of the chautauqua summer seasons. It has also been demolished. The street was named for the ravine just to its south.

These two postcards from about 1910 show Harris Avenue. This well-traveled dirt road was a major north–south roadway through the village. In 1898, reacting to a popular movement to extend Sheridan Road from Chicago north through the suburbs, Harris Avenue became part of Lake Bluff's Sheridan Road. During the 1920s, this roadway was renamed Moffett Road, in honor of Capt. William Moffett, who served as commandant of the Great Lakes Naval Training Station during World War I.

This view is looking east on Ravine Avenue toward the lake near its intersection with Simpson Avenue. Spring Cottage, a well-known summer boardinghouse, is on the right. There were many of these small hotels and boardinghouses throughout the village. They were popular during the Lake Bluff Camp Meeting days, and some, like Spring Cottage, lasted through the early years of the 20th century.

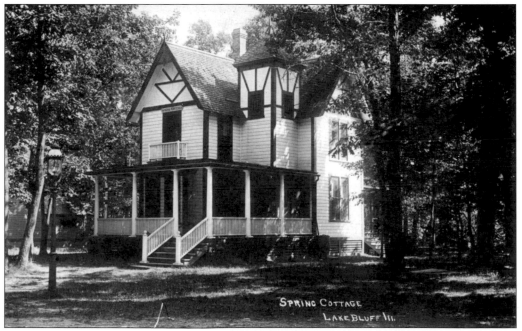

This postcard shows a full photograph of Spring Cottage as it originally looked in the resort days. The cottage has been significantly altered through the years and no longer resembles its original design. It is located at 631 Ravine Avenue.

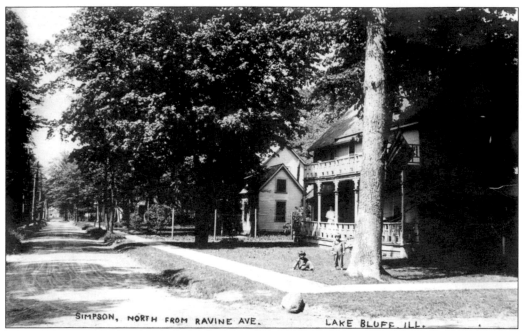

SIMPSON, NORTH FROM RAVINE AVE.　　LAKE BLUFF, ILL.

This postcard shows Simpson Avenue looking north from Ravine Avenue. The cottages, only a block from the lake, were more substantial than some of the others built during the same period. Simpson Avenue was named for Bishop Matthew Simpson, a prominent Methodist minister and frequent visitor to Lake Bluff Camp Meeting events. The postcard below shows the intersection of Ravine and Simpson Avenues in 1938, looking east. The Lannon stone house was new, and the house on the corner has been enlarged from the earlier cottage in the postcard above. In the distance is the Rev. Mathew Parkhurst cottage, facing Sunrise Avenue.

RAVINE AVE - LAKE BLUFF

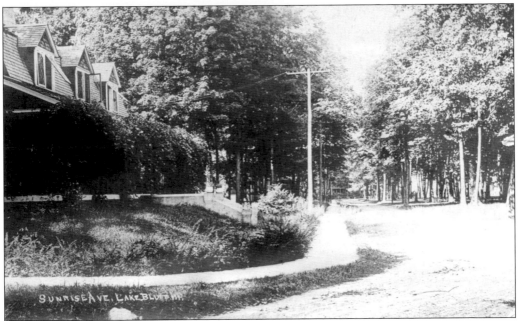

This view is of the northwest corner of Ravine and Sunrise Avenues. This was Rev. Mathew Parkhurst's residence. The house was unusual because the first floor was built with a concrete mixture using sand from the beach. Parkhurst named his home Ivy Bank after a family residence in Scotland. It is said that the house contained a bowling alley in the basement that went under Sunrise Avenue. Parkhurst was the pastor of the Grace Methodist Episcopal Church in Chicago and was instrumental in rebuilding that church after it burned in the Chicago fire of 1871. In Lake Bluff, he helped organize the chautauqua's Sunday school assemblies. The postcard below is another photograph of Ivy Bank as it looked originally with its porch across the front of the home.

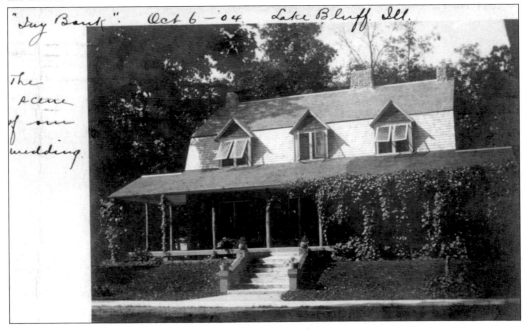

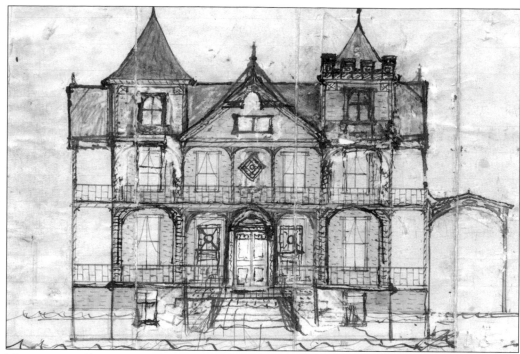

The Honeywell–Beall House on the northwest corner of Sunrise Avenue and Park Place was originally a duplex facing south. It was built in 1889 for the Honeywell and Evans families, and Honeywell soon had the duplex turned so both units faced the lake. It later became a single-family home for the Honeywells, later joined by their daughter and son-in-law, Rev. Thomas Beall. A tower was added for each of the two Beall daughters as special playrooms. Although major rehabbing has taken place, the front of the home retains its original features and is easily recognized. Alba Honeywell was a prosperous farmer from Hoopstown, and Gaylord Evans was the president of Hedding College, attended by Honeywell's four daughters. Evans was also in charge of the Lake Bluff Camp Meeting Association's cultural programs. The image above shows the architect's rendering of the home.

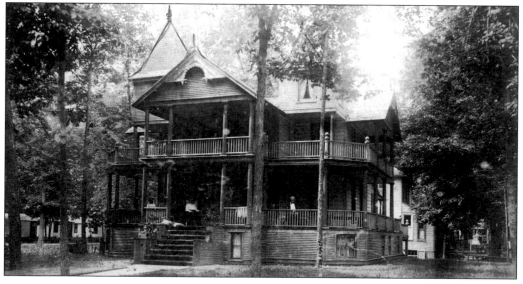

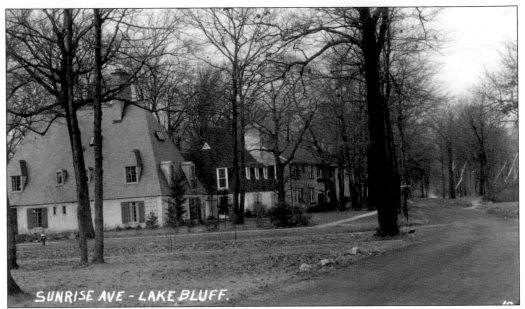

Sunrise Avenue is seen in a view looking north in 1938. The two French eclectic homes on the left were built around 1928. The house facing the corner was the home of Donalee Taburn. Taburn, a chemist and inventor, was associated with Abbott Laboratories for many years. He is credited with the discovery of Nembutal and Pentothal, two well-known sleep drugs. Pentothal was commonly referred to as the "truth serum" drug.

Sherwin and Marian Cody's cottage was on Simpson Avenue looking toward Lakefront Park. Sherwin Cody, the cousin of "Buffalo Bill" Cody, was an editor and author of books and pamphlets on the use of the English language. Sherwin and Marian were part of the "artist's colony" on Park Place, along with other artistically talented neighbors. Dissatisfied with the more mundane activities of the local ladies, Marian Cody formed a women's circle for "cultural conversation."

Shown above is the Pink Palace, named for the pink-hued stucco used when the house was built in 1905. It was the home of William and Alice Corbin Henderson. William Henderson was an artist associated with the Art Institute of Chicago and later would become well known as a painter of southwestern New Mexico. Alice Corbin Henderson was the coeditor of *Poetry* magazine and invited Joyce Kilmer and Vachel Lindsey, among others, to her home. Next door to the Henderson home was the Italian Renaissance house of Otto and Marguerite Kruetzberg, designed by architect Arthur Huen. The residence, built in 1910 on Park Place, is distinctive with its widow's walk. Marguerite was a prominent local artist. In 1926, she painted the mural that hangs in the gymnasium of East Elementary School depicting the explorers Jacques Marquette and Louis Jolliet meeting with the Native Americans on the bluff overlooking Lake Michigan.

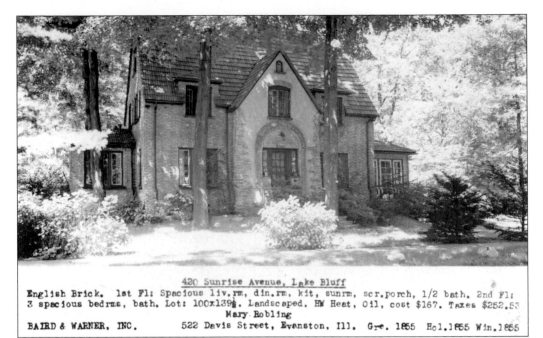

420 Sunrise Avenue, Lake Bluff

English Brick. 1st Fl: Spacious liv.rm, din.rm, kit, sunrm, scr.porch, 1/2 bath. 2nd Fl:
3 spacious bedrms, bath. Lot: 100x139½. Landscaped. HW Heat, Oil, cost $167. Taxes $252.53
Mary Robling
BAIRD & WARNER, INC. 522 Davis Street, Evanston, Ill. Gre. 1855 Hol.1855 Win.1855

This postcard from the Baird and Warner Real Estate Agency was sent out in 1948 advertising the sale of the house at 420 Sunrise Avenue. Notice that the taxes were only $252.53 for this lakefront property. In the 1980s, a major addition was put on the house, yet it retains the integrity of the original structure.

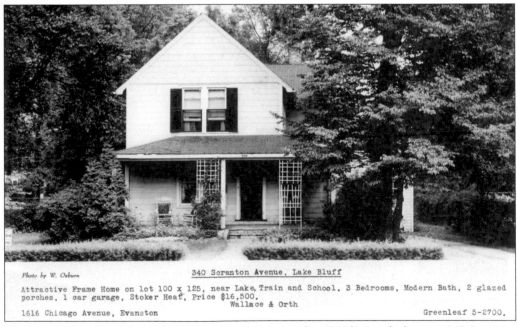

Photo by W. Osburn 340 Scranton Avenue, Lake Bluff

Attractive Frame Home on lot 100 x 125, near Lake, Train and School. 3 Bedrooms, Modern Bath, 2 glazed
porches, 1 car garage, Stoker Heat, Price $16,500.
Wallace & Orth
1616 Chicago Avenue, Evanston Greenleaf 5-2700.

The North Shore Real Estate Agency sent out this postcard in 1948 listing the home at 340 Scranton Avenue for sale at $16,500. This was an unusually large lot listed for Lake Bluff at 100 feet by 125 feet. Substantial alterations were made to the home, but it was demolished in 2003.

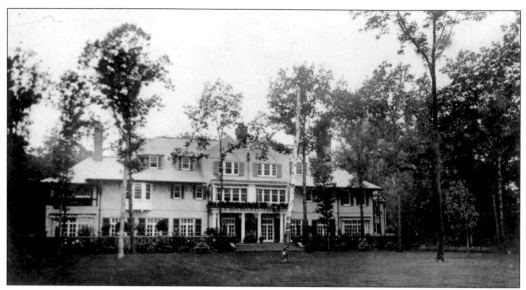

Several Chicago millionaires built large mansions before World War I along the bluffs overlooking the lakefront. Among the first was the imposing country residence of Stanley Field, nephew of Marshall Field and president of the Field Museum. He had purchased 33 acres along the lake and built his home in 1909 at the end of a long tree-lined drive, now Lakeland Drive. To design his home, Field hired the architectural firm of Daniel Burnham, well known for supervising the design and construction of the 1893 World's Columbian Exposition and for preparing "the Plan for Chicago." Stanley Field died in 1965, the house was demolished in 1967, and the estate was subdivided. The postcard above shows a view of the house from the lakefront. Field had several outbuildings on his estate. One of them was a gardener's duplex cottage, shown below, which actually was located on Ravine Avenue and was connected to the main grounds by a wooden footbridge across the ravine. In the 1980s, the duplex was renovated into a single-family residence.

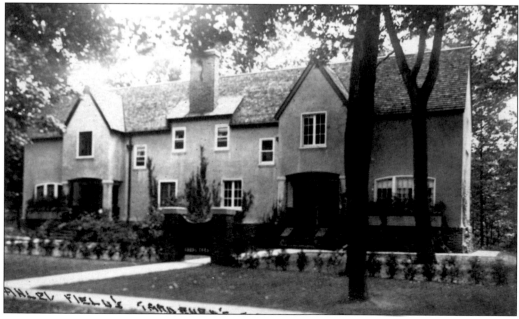

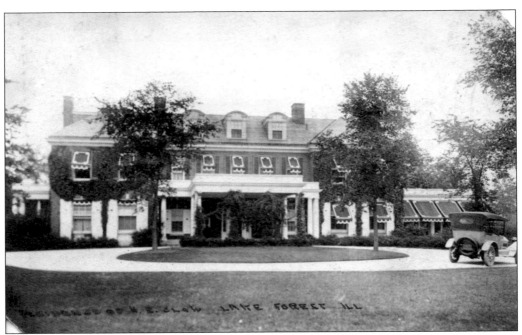

Harry Clow, president of Rand, McNally and Company, purchased 21 acres south of Field's land in 1911 and hired Benjamin Marshall as his architect. Marshall, who designed the Drake Hotel among other Chicago landmarks, worked with landscape architect Jens Jensen to create the estate of Lansdowne. It included a polo field, an outdoor theater, and a swimming pool. The Clow family owned the estate until 1985. In 2007, it was sold to a developer who has subdivided the property but plans to retain the mansion and coach house. Although both postcards identify the house as being in Lake Forest, they are incorrect. The Clow estate was located in Lake Bluff.

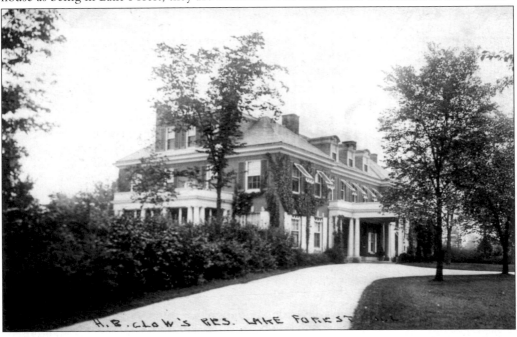

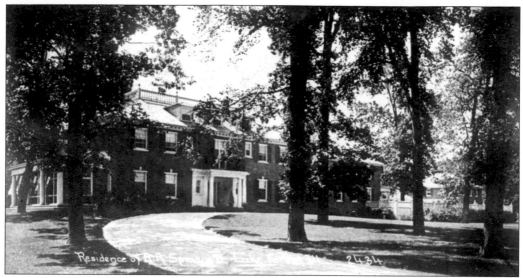

In 1911, Albert A. Sprague II purchased 33 acres immediately south of Stanley Field's property on what is now Forest Cove Road. Sprague was chief executive officer of Sprague, Warner and Company, a prominent Chicago firm, and his wife was the niece of Marshall Field and cousin of Stanley Field. Sprague hired architect Harrie Lindeberg to build a Georgian Colonial Revival home. In the 1930s, Julian Armstrong, the next owner, hired architect Jerome Cerney to redesign the home, dramatically altering the outside facade of the house. The estate was subdivided in the 1960s.

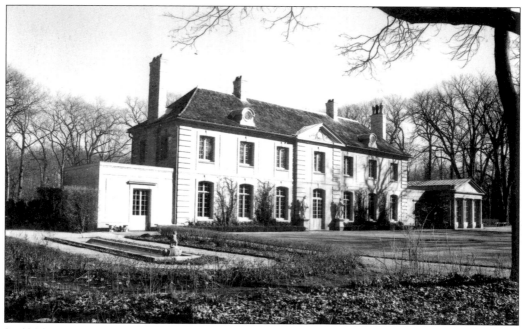

In 1923, Mrs. C. Morse Ely built Le Lanterne on the property just north of the Clow estate. She hired well-known architect David Adler to design the residence, modeled after the famous La Lanterne estate at Versailles. In the 1950s, the north wing of the house was detached and moved farther west to become a separate residence. The two gatehouses and the orangery are now used as private homes.

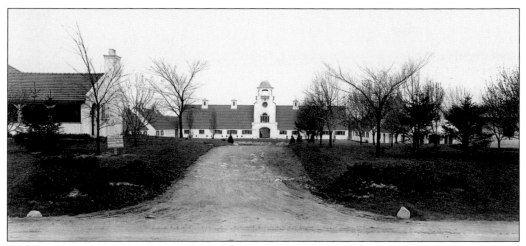

Henry Blodgett, a judge of the U.S. district court in Waukegan, owned a large 300-acre dairy farm on Sheridan Road just north of Lake Bluff in the late 19th century. When Blodgett died in 1905, the farm was sold to Scott and Grace Durand, socially prominent Lake Forest residents. They hired architect Solon Beman to design new farm buildings. Beman is known for designing Pullman Village in Chicago, as well as other Chicago landmarks. The Durands called their dairy Crab Tree Farm, and Grace Durand successfully ran the dairy. Crab Tree Farm is still a working farm.

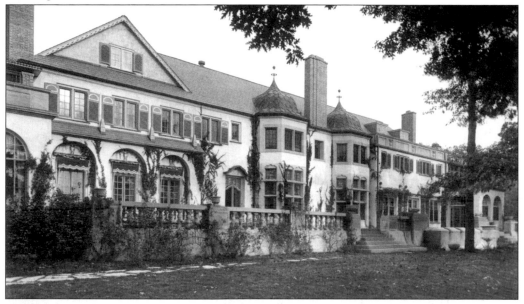

William V. Kelley, a Chicago manufacturer and financier, purchased 130 acres on the west side of Green Bay Road in 1916 and hired Howard Van Doren Shaw to design a manor home and gatehouse for his family. Landscape architect Jens Jensen created a curving entrance road with a stone bridge over a lagoon. The home, known as Stonebridge, was sold to Walter Patton Murphy, a Chicago industrialist, in 1934. It was sold to the Servite Order in 1942 and became known as Stonebridge Priory. Harrison Conference Services of New Jersey purchased the property in 1969 and used it as a convention center and hotel. Currently the estate is being subdivided for single-family and duplex homes, with the manor home and coach house converted to condominiums.

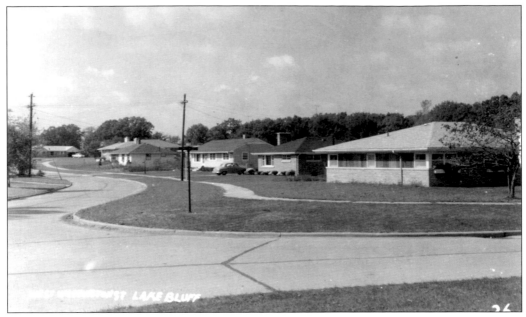

It was not until after World War II and the emerging baby boom that new subdivisions were created in Lake Bluff. The North Terrace, bordered by Green Bay Road on the west and Rockland Road on the south, was built up in the early 1950s. Many of the homes were affordably priced ranch houses. Development soon followed in the East and West Terraces during the late 1950s and early 1960s.

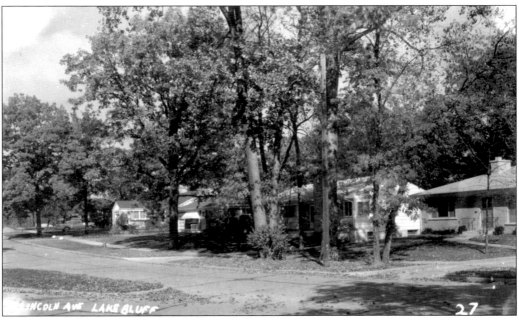

The postcard above shows North Lincoln Avenue in the North Terrace as it appeared in the 1960s with mature landscaping and vegetation.

Four

READING, WRITING, AND RELIGION

Early-19th-century settlers considered a community to be established and permanent if it offered churches and a school to the inhabitants. The Dwyer settlement, anchored by the Dwyer family's tavern and stagecoach stop on the west side of Green Bay Road just north of what is now known as Rockland Road, was served by St. Anne's Church and supported by a circuit priest. This first church was built for the Irish Catholic immigrants who had settled in the area. The church was a simple log cabin built about 1844 on one and a half acres of land donated by the Dwyer family.

The Rockland Union Church was organized in 1866; it met in a frame building at the southeast corner of Green Bay and Rockland Roads. It served the community until 1902, when the building was torn down to make way for the Chicago and Milwaukee Electric Railway's new tracks running west to Libertyville. That congregation then joined with newcomers to the village and formed the Union Church of Lake Bluff in 1908.

The Grace Methodist Episcopal Church was organized in 1888 and erected a building on the southeast corner of Center and Scranton Avenues. It was torn down in the early 1900s when it was found that it stood on the village's right-of-way. Although the original places of worship no longer exist, today's Union Church and the Grace Methodist Church are an integral part of the community.

The first public school was built on the northeast corner of Green Bay and Rockland Roads in 1869, across from the Rockland Union Church. The "Little White School" was a one-room wooden structure in which one teacher taught all grades. As the town grew, a four-room brick school was built on the east side of town in 1895. Known as the Lake Bluff School, it was enlarged in 1923, followed by two more additions after World War II.

Lake Bluff's population continued to grow, and a junior high school was built for the seventh and eighth grades in 1955 on property adjacent to the elementary school. In the 1960s, the West and Central Elementary Schools were opened. As of now, a new and larger elementary school building is being planned to open in 2009 for all kindergarten through fifth-grade students.

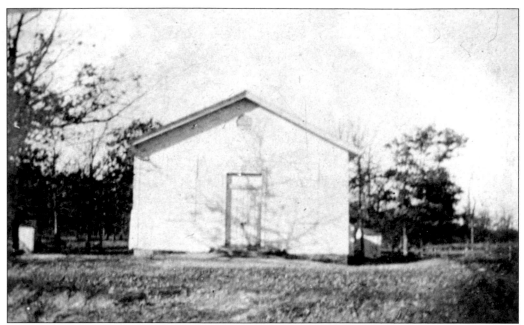

The first schoolhouse was built in Lake Bluff in 1869. It was a one-room white frame building near the northeast corner of what is now Route 176 and Green Bay Road. The land for the school was purchased from early settler Edward Mawman for the sum of $35. Known as the "Little White School," it was the only school in the community until 1895, when the newly incorporated village built a four-room brick school on the east side of town. The one-room school continued to serve students on the west side until 1904, when it became a "pest house" for contagious patients. In 1910, the abandoned schoolhouse was donated to a Baptist mission and moved to Rondout where it was later converted to a private home.

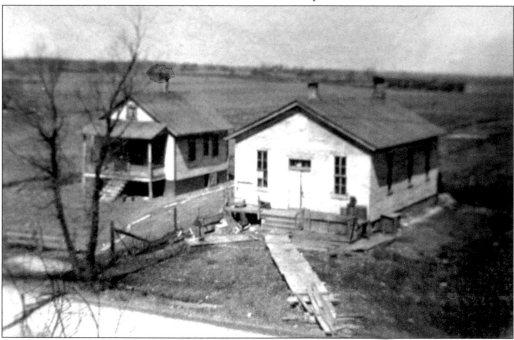

Reward of Merit.

In the late 1800s, good work by deserving students was often acknowledged with a "Reward of Merit." The award came in various sizes and usually had a colorful lithograph on the front. These cards were highly prized by their recipients and were often proudly displayed in their homes. This cherished Reward of Merit card was presented to a student who attended the Lake Bluff School in the 1890s.

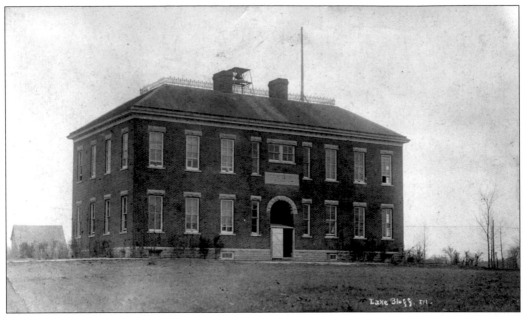

The postcard above shows the new four-room brick school, built in 1895 on East Sheridan Place for Lake Bluff children from first through the eighth grades. The bell originally used during the Lake Bluff Camp Meeting days to call the summer visitors to the assemblies was placed on the roof of the new school. The barn seen in the left background sat on land that was farmed into the 1920s.

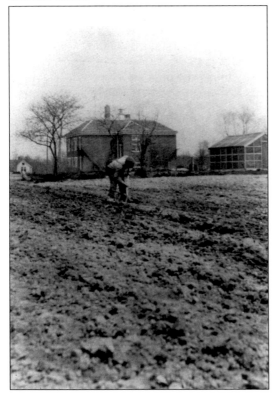

The photograph to the left with the school in the background shows a farmer tilling land in the area of Circle Drive and East Witchwood Lane. A barn is on the right, and East Sheridan Place can be seen in the distance. This photograph emphasizes that Lake Bluff still retained its rural roots.

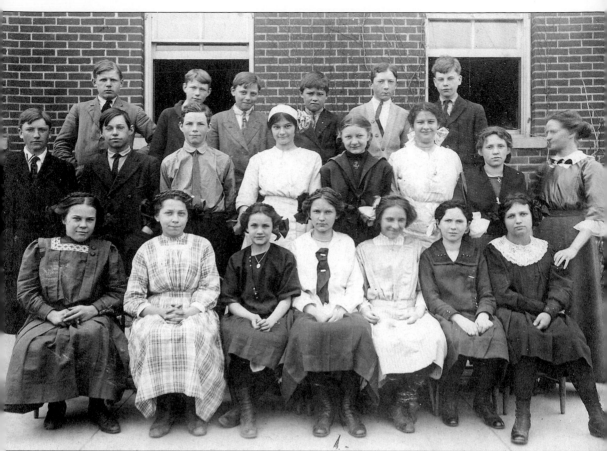

The Lake Bluff School's seventh and graduating eighth grades are seen in the spring of 1913. The photograph was taken in front of the school. The *Lake Bluff Chat*, for June 21, 1913, recorded, "Friday evening the Lake Bluff School graduated the largest class in its history. The Club House was filled with a well dressed audience who listened with interest to the program. Prof. Van Steenderen, the speaker of the evening, gave a very interesting talk on the difficulties and limitations in the education of the American child. The musical numbers were especially fine. Mrs. Mandeville sang two numbers with her usual sweetness and charm of voice and manner, little Marion Cook accompanied by her teacher, Mrs. Rykof played a brilliant violin solo. Mr. Rankin presented diplomas to the following graduates: Ruth Daley, Edna Daley, Gertrude Grost, Beulah Shaffar, Lillite Likkonen, Earl Charlston, Leopold Grost, Archie Miller and Arthur Wickstrand."

Lake Bluff School

The number of students was increasing in the growing community, and the Lake Bluff School needed more room to serve them. Seven classrooms and a gymnasium/auditorium were added to the front of the old building in 1923. Progressive for its time, the seven new classrooms were placed around the perimeter of the gymnasium, which also included a projection room, thus providing a community theater of sorts, showing silent movies to residents on weekends. This new addition's front facade has remained unchanged through the years. The architectural firm of Howard Van Doren Shaw was hired to design an outdoor theater just west of the school to be used for graduations and class plays—only remnants of that landscape remain. The lantern slide below was found in the old projection room. It advertises the upcoming film for September 1926.

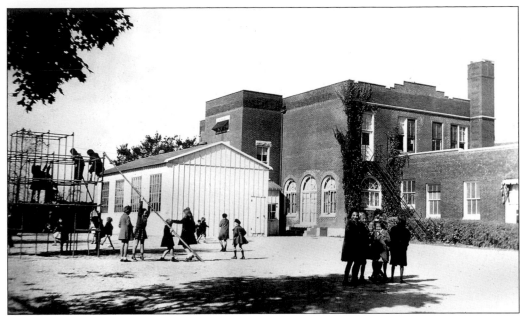

Growing enrollment in the mid-1930s necessitated increasing classroom space, but the village, like the rest of the country, was in the midst of the Great Depression. A temporary prebuilt classroom was added in 1934. This picture, taken in 1937, shows the add-on classroom located at the rear of the school. It was later used as a garage and was torn down in the late 1990s. It was not until after World War II that another addition was needed. A one-story west wing addition was ready for the 1947 school year, and in 1950, with more school-age children than ever in the village, a second floor was added.

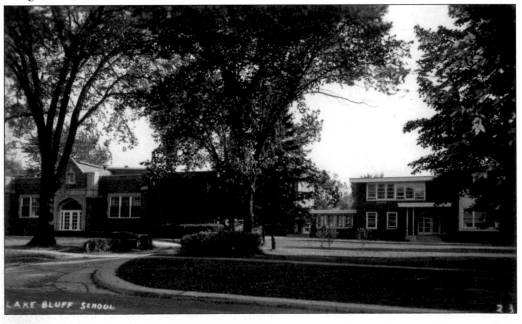

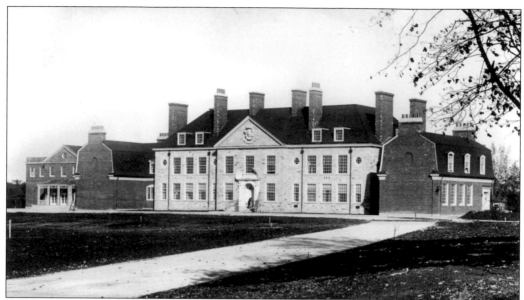

Lake Bluff was not part of a high school district until 1934. Students completing eighth grade had three choices for high school: the Deerfield-Shields School in Highland Park, Libertyville High School, or Waukegan High School. Fortunately, students could travel to all three schools on the North Shore Line. In 1934, Lake Bluff voted to become part of the Deerfield-Shields District and joined Lake Forest residents in a campaign to place a high school within their own communities. The opportunity to receive funding for labor and materials from the federal WPA provided the impetus for the Deerfield-Shields District to build a new high school in Lake Forest. The local architectural firm Anderson and Ticknor was hired to design a school that resembled one of the local mansions. This school opened in 1935, and although several additions have been made over the years, the outstanding Georgian front facade has never been altered. Lake Forest Community High School separated from the Deerfield-Shields District in 1949, forming School District 115.

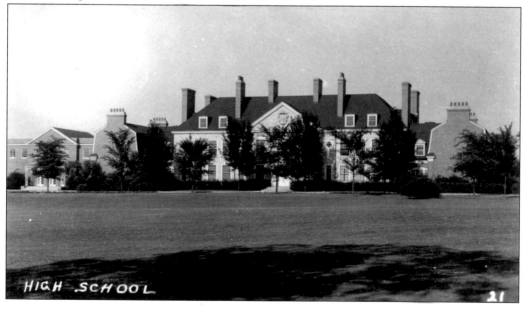

The dedication of this new Methodist church building took place in 1891. Standing on the southeast corner of Center and Scranton Avenues, it was named the Grace Methodist Episcopal Church. The church was built to serve the growing Methodist congregation that had held summer services in the tabernacle and winter services in the Lake Bluff Camp Meeting headquarters. Its first pastor was Dr. A. J. Jutkins, who had served as minister of Chicago's Grace Methodist Church. This building was later torn down when it was found to have been built on the public right-of-way.

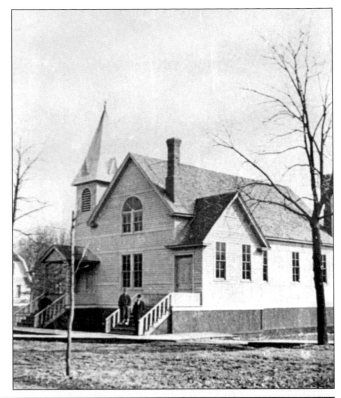

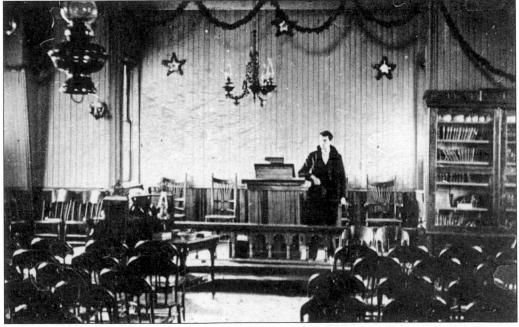

This photograph shows Rev. Frank Barnum, who became pastor of Grace Church in 1896, standing in front of the church's pulpit. He was well liked and respected throughout the village and was referred to as the "Little Minister" by Grace Cloes. Barnum left in 1899, but he and his wife returned to live in Lake Bluff after his retirement in 1938.

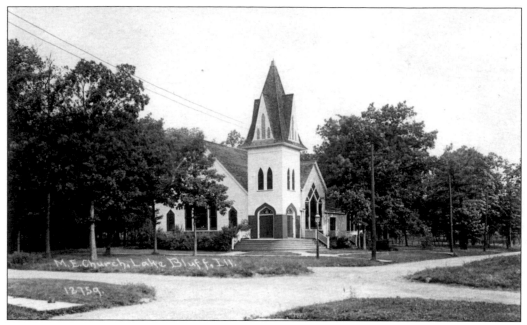

The postcard above shows Grace Methodist Church about 1903, soon after it was built on the northwest corner of Center and Glen Avenues as a replacement for the earlier building that had to be demolished. The postcard below shows the 1948 addition and the architectural changes that were made to the original church building. The facade was covered with Lannon stone, and the church spire was significantly altered. With some additional modifications, the church remains very much the same as it was in the late 1940s.

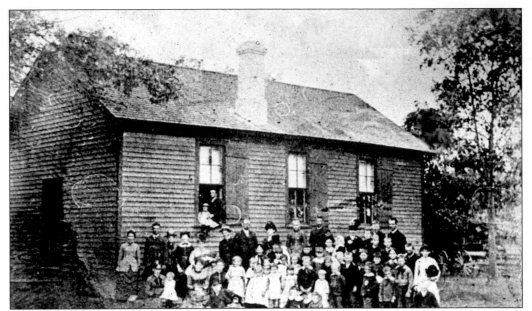

In 1866, on the southeast corner of Green Bay and Rockland Roads, the Rockland Union Church was built. Known as the "Little Brown Church," it would serve the community until it was torn down at the dawn of the 20th century to make way for the electric trolley line's tracks to Libertyville. For several years, the church members met on the second floor of the country club.

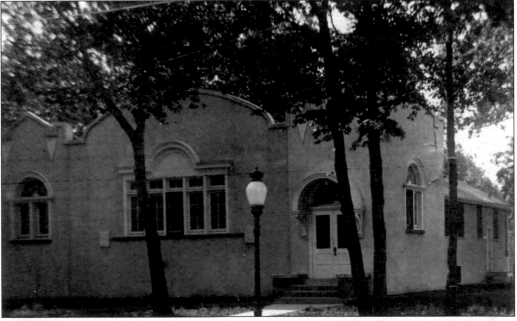

In 1920, an old YMCA hostess hall from the Great Lakes Naval Training Station was purchased and placed on the site of the old Lake Bluff Camp Meeting tabernacle. It served the newly organized Lake Bluff Union Church under the leadership of Rev. Nelson Hall. The home directly to the east of the new church was bought as the minister's residence. The original Bible from the old Rockland Union Church was donated to the new group.

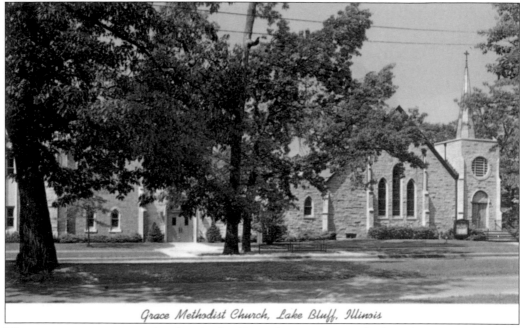

Grace Methodist Church, Lake Bluff, Illinois

These more recent postcards taken in the 1970s show Grace Methodist Church and the Lake Bluff Union Church as they look today. A more recent addition to the west of Grace Methodist Church is shown as is the major 1965 renovation to the Lake Bluff Union Church that totally changed its architectural style.

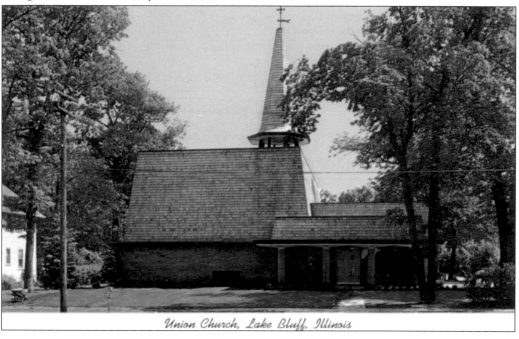

Union Church, Lake Bluff, Illinois

Five

UPTOWN, DOWNTOWN, ALL AROUND THE TOWN

When the village was called Rockland in pre–camp meeting days, the "business district" consisted of a tavern, a boardinghouse, and a combination general store/post office. They were located on Mawman Avenue near the railroad and served the little farm community until the 1870s. The community's new name, Lake Bluff, came with the Lake Bluff Camp Meeting bringing many visitors to the new summer resort. The commercial area was then relocated to its present position on Center and Scranton Avenues.

In the early 20th century, most of the commercial buildings in Lake Bluff's "uptown" were simple one-story frame structures. They included a bakery, a grocery, an ice-cream parlor, a real estate office, and the post office. The oldest commercial building in town, the Village Market, at the northwest corner of Walnut and Scranton Avenues, has always housed a grocery store. It was built of brick about 1902, replacing an earlier frame store that had opened in the 1880s. The building was extensively renovated in 2006.

Two significant brick buildings were erected at the beginning of the 20th century, establishing a definitive town center for the village. First, the train depot was built by the Chicago and North Western Railroad in 1904 on the west side of Sheridan Road at the Scranton Avenue intersection. The village boasted two railroads at that time as there was also the electric trolley line connecting Chicago with Milwaukee. The second key building, the village hall, was erected in 1905 with $6,500 from contracts with the Chicago and North Western Railroad. Designed by Webster Tomlinson, a Chicago architect and former business partner of Frank Lloyd Wright, it has become the symbol and landmark for Lake Bluff.

The uptown area continued to keep pace with village growth. In the 1920s, brick buildings housing both retail and offices were erected along Center Avenue and the south side of Scranton Avenue. In the 1950s and 1960s, the north side of the street was developed for commercial use. The architectural significance of the uptown's oldest buildings was recognized in 2007 when they were placed on the National Register of Historic Places.

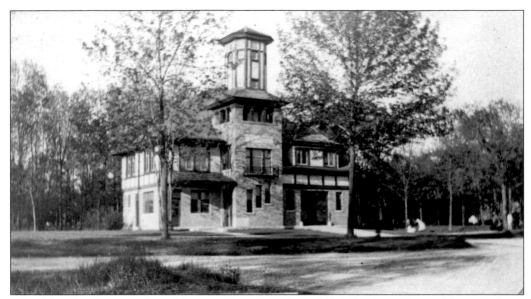

Lake Bluff has been anchored by its village hall since 1905. Designed by architect Webster Tomlinson, who had for a time been Frank Lloyd Wright's business partner, the building originally housed the municipal offices and the police and volunteer fire departments. The tower provided a hanging space to dry the canvas fire hoses.

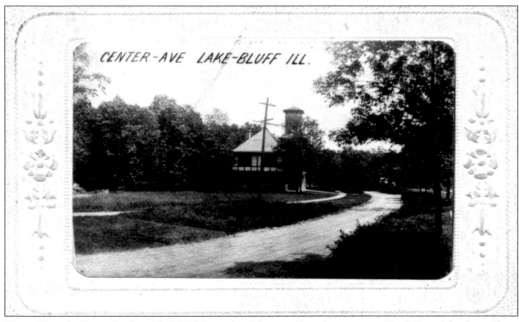

CENTER-AVE LAKE-BLUFF ILL.

The village hall was built with $6,500 received from railroad contracts. Fred Cornish, the village president, and his wife donated the land on which the building was erected. In the 1930s, when the tower needed repairs that the village board could not afford, the tower was removed. It was replaced in honor of the village's centennial in 1995 through contributions from residents.

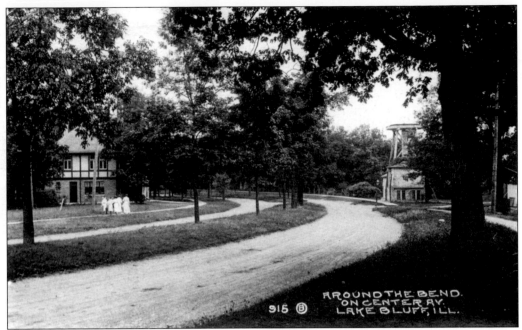

AROUND THE BEND.
ON CENTER AV.
LAKE BLUFF, ILL.

915 B

The postcard above dates from around 1910. The structure to the right was the original village water tower. A village green was created across the street after the Lake Bluff Welfare Association was organized to promote civic improvements to enhance the natural beauty of the village. It acquired the land in the name of the village and removed several buildings in order to make the new green more attractive. A large new water tower was built in the 1920s and stood as a local beacon at the entrance to town until the 1980s, when it was replaced by the current water tower near the public works building on Route 176.

LAKE BLUFF

WATER TOWER LAKE BLUFF 29

TABLET IN HONOR OF THE PARTICIPANTS
IN THE WORLDS WAR
LAKE BLUFF ILL

The village erected the war memorial on the village green in 1919, paid for with money remaining from the funds raised by villagers during World War I to send an ambulance and driver to France. The memorial commemorated the 78 servicemen from Lake Bluff who fought in that war. More names were added after World War II, and the memorial was expanded in the 1990s to include those who served their country from the Civil War through Vietnam. Below is the ambulance that was sent to France during World War I with funds raised by the village. Local resident John Kruetzberg was sent along as the driver. The *Chicago Tribune* called Lake Bluff the "most patriotic town in America" for the number of villagers who joined the armed forces and the amount of money raised by the community for the war effort.

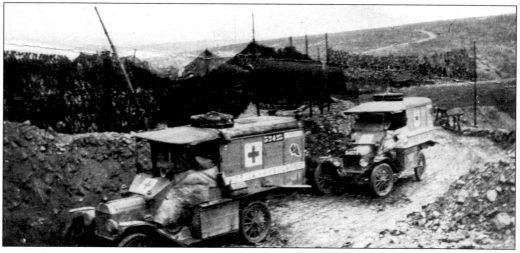

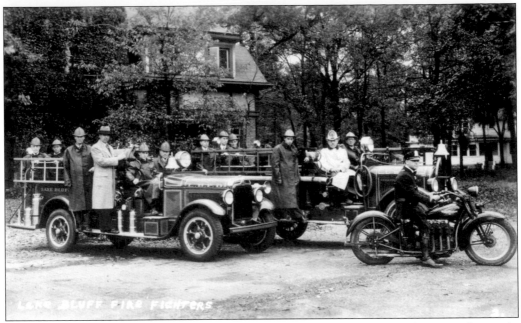

This 1929 photograph shows the Lake Bluff Volunteer Fire Department with its new fire truck. The old truck is in the rear. Charles Helming, fire chief from 1911 to 1947, is the man in the white hat. Police chief Eugene Spaid is on the motorcycle, the first motorized vehicle owned by the police department. Previously a bicycle was used to patrol and to flag down speeding motorists. In 1928, a sensational mystery surrounded a young woman found burned to death in the basement of the village hall. It made national news and apparently involved Lake Bluff's night police officer. It has never been solved.

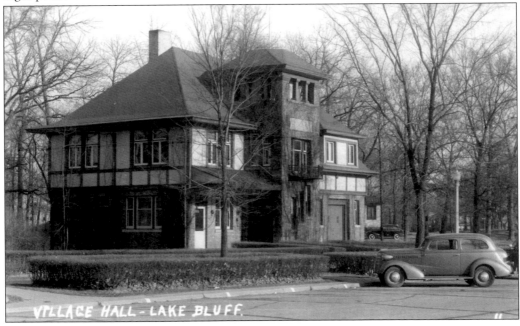

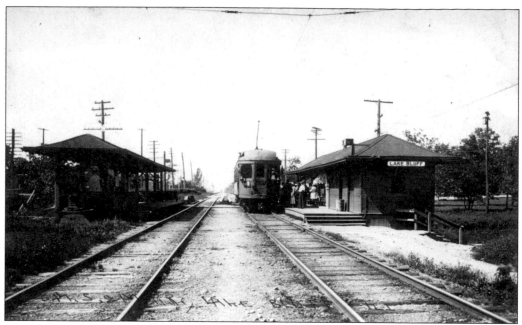

The electric trolley line, later known as the North Shore Line, purchased land in 1902 and put in a two-track line through Lake Bluff along what is now Sheridan Road. The tracks were laid on the original roadway, and the street was moved 50 feet to the east. This electric line connected Lake Bluff to Chicago and Milwaukee with a spur line to Libertyville and Mundelein. The postcard above shows passengers at the electric line's depot, located about 100 yards north of the current Metra station. The card below shows the spur line west to Libertyville. The North Shore Line went out of business in January 1963.

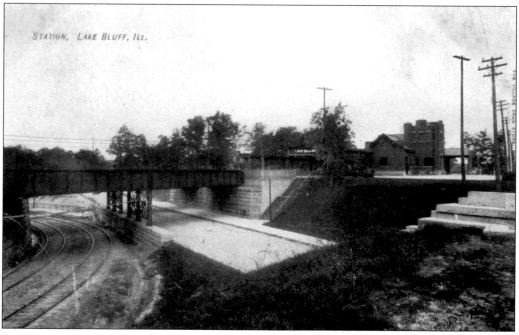

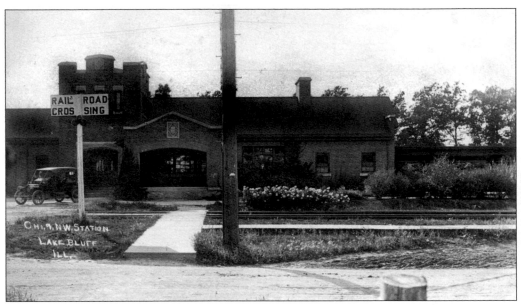

The view in the postcard above shows the east-facing entrance to the northwestern depot around 1920. The station was built in 1904 by the architectural firm of Granger and Frost, which designed many of the train stations along Chicago's North Shore. The original wooden station was moved farther north to become a freight station. The postcard below is another view of the northwestern depot with a locomotive entering the station. In 1979, the station underwent a major renovation and remains today as the defining landmark on the west edge of the downtown area.

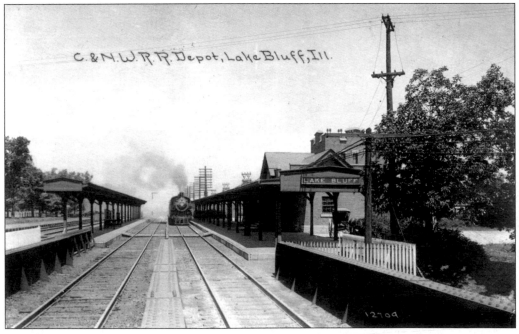

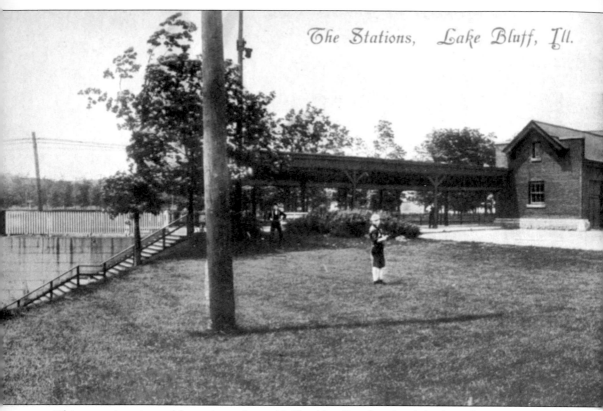

The Stations, Lake Bluff, Ill.

This sweeping view of the train station with Sheridan Road to the right dates from around 1910. On the left can be seen the stairway that leads to the Rockland Road underpass. The electric railroad's tracks ran directly in front of the northwestern station, and its passenger station can be

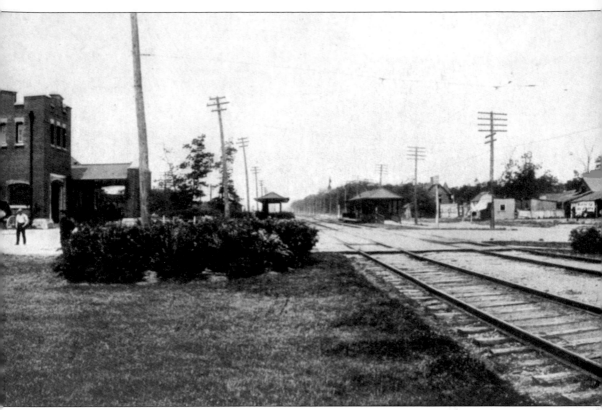

seen in the distance. The ramshackle buildings across the road stood on the edge of the uptown area. They would remain until the 1920s, when the village began to upgrade its image and made an effort to eliminate unsightly buildings in the business district.

This view shows Scranton Avenue as one looks west toward the train station. The brick building on the right known as Rosenthal and Helming's Grocery and Meat Market was built about 1902. That building still stands as the Village Market, the oldest commercial building in town.

In 1918, a huge snowstorm blanketed northern Illinois and life came to a standstill in Lake Bluff. Capt. William Moffett, the commandant at the Great Lakes Naval Training Station, sent his sailors to help dig out the village. This photograph shows some of them shoveling the snow in front of Rosenthal and Helming's.

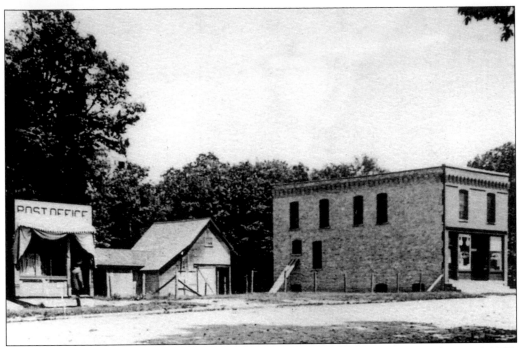

Above is the Rosenthal and Helming's Grocery and Meat Market as it appeared around 1915. Charles Helming was the stepson of Adolph Rosenthal, who had opened a grocery and meat market around 1880. After Adolph's death in 1902, Charles took over the operation of the store. Very active in village affairs, Helming joined the Lake Bluff Volunteer Fire Department and served as chief from 1911 until 1947. The photograph below shows Charles Helming, in his butcher's apron, standing in front of his new brick grocery built after a fire destroyed the earlier wooden one.

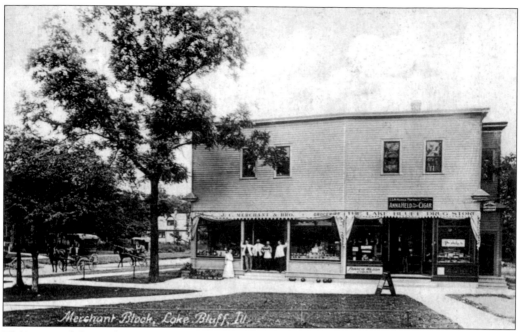

This postcard shows the Merchant Block, named for its owner, J. C. Merchant. Dating from about 1902, it was built with lumber from the Grace Methodist Church that was torn down because it had been erected in the public right-of-way. The Merchant Block was destroyed by fire in 1917, even though the volunteer fire department was located next door in the village hall.

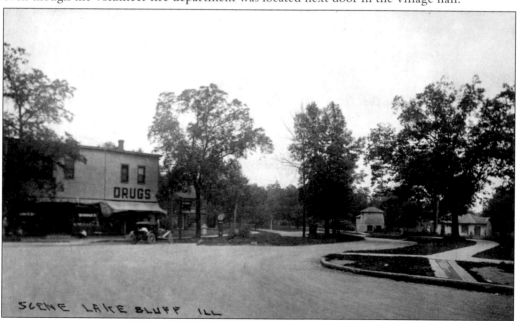

This view is looking south from Rosenthal and Helming's Grocery toward the Merchant Block, with the village green on the right. The large Drugs sign marked the local pharmacy, and another grocery store was located in the north end of the building. This grocery was originally owned by J. C. Merchant, who later sold it to the Miller brothers. A gas pump was added to service the growing number of automobiles in the village.

122

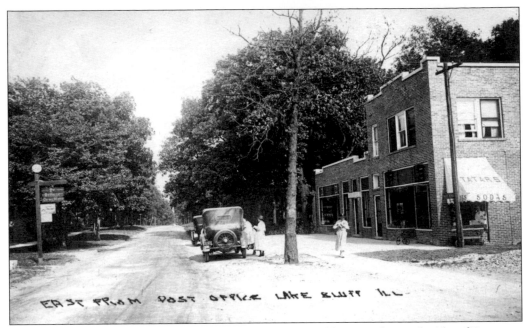

In the early 1920s, Mrs. E. B. Tatar built this brick building on the south side of Scranton Avenue to house her tearoom and the post office. Her apartment was on the second floor above the restaurant. The building was rebuilt after a fire in 1923 with apartments extending across the entire second story.

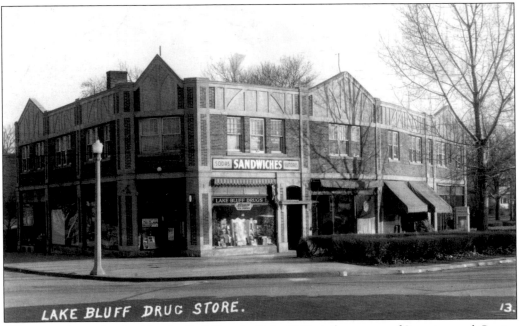

This view shows the Sankiewicz Building, built in 1925 at the corner of Scranton and Center Avenues. Chester Sankiewicz owned the building and operated the pharmacy. Offices and stores occupied the rest of the first floor, with rental apartments on the second floor.

The postcard above shows the residence of pharmacist Graham Munch, who opened a drugstore in his home after the Merchant Block drugstore burned in 1917. When Munch retired in 1959, he donated his building to the library on the condition that he retain his residence on the second floor for the rest of his life. This building served as the Lake Bluff Library until 1975, when it moved to its current location at Oak and Scranton Avenues.

When Graham Munch retired, he sold his business to his assistant, Howard Willms, who built this new brick building just east of the Munch residence to house the Lake Bluff Pharmacy. The store remained in that location until the mid-1970s, when Willms built a brand-new building on the site of the original pharmacy. The new Lake Bluff Pharmacy closed in the late 1990s, and other businesses now occupy both buildings.

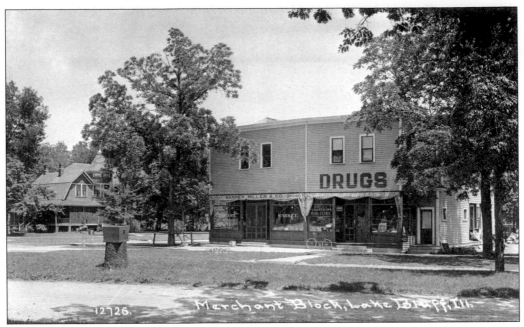

This excellent real-photo postcard shows the Merchant Block with Warren Miller's grocery on the left. A very large man, Miller was known as "Tiny" to his customers. Next to his store was a real estate agency and the Lake Bluff Drug Store anchored the end of the building. The recent postcard below shows a photograph of Holly's Bistro, which stands in the same location as Warren Miller's grocery store did so many years ago.

This postcard photograph by Steve Regul shows a newly renovated Village Market, formerly known as Rosenthal and Helmings Grocery Store. The back addition built sometime after World War I now houses a butcher shop and delicatessen with offices on the second floor. This renovation of the oldest uptown building characterizes the "renaissance" of the village's business district. It symbolizes the value and appreciation that the residents of Lake Bluff have of their heritage and history.

BIBLIOGRAPHY

Blanchard, Belinda S., and Susan S. Benjamin. *An Architectural Album: Chicago's North Shore.* Evanston, IL: Junior League of Evanston, Inc., 1988

Cohen, Stuart, and Susan S. Benjamin. *North Shore Chicago: Houses of the Lakefront Suburbs, 1890–1940.* New York: Acanthus Press. 2004

Ebner, Michael H. *Creating Chicago's North Shore.* Chicago: University of Chicago Press, 1988.

Halsey, John J. *A History of Lake County, Illinois.* Philadelphia: Roy S. Bates, 1912.

Nelson, Janet, and Kathleen O'Hara. *Lake Bluff Illinois, A Pictorial History.* Lake Bluff: Village of Lake Bluff Centennial Committee, 1995.

Vliet, Elmer. *Lake Bluff: The First 100 Years.* Chicago: R. R. Donnelley Sons and Company, 1985.

Willard, Frances. *Glimpses of Fifty Years 1839–1889.* Chicago: Woman's Temperance Publication Association, 1889.

ACROSS AMERICA, PEOPLE ARE DISCOVERING SOMETHING WONDERFUL. *THEIR HERITAGE.*

Arcadia Publishing is the leading local history publisher in the United States. With more than 3,000 titles in print and hundreds of new titles released every year, Arcadia has extensive specialized experience chronicling the history of communities and celebrating America's hidden stories, bringing to life the people, places, and events from the past. To discover the history of other communities across the nation, please visit:

www.arcadiapublishing.com

Customized search tools allow you to find regional history books about the town where you grew up, the cities where your friends and family live, the town where your parents met, or even that retirement spot you've been dreaming about.